WHAT ART IS

ARTHUR C. DANTO

Yale UNIVERSITY PRESS NEW HAVEN & LONDON

yalebooks.com/art

Designed by Nancy Ovedovitz and set in Scala type
by Integrated Publishing Solutions. Printed in the
United States of America.

The Library of Congress has cataloged the hardcover edition
as follows:
Danto, Arthur C., 1924–
What art is / Arthur C. Danto.
p. cm.
Includes bibliographical references and index.
ISBN 978-0-300-17487-8 (hard cover: alk. paper)
1. Art—Philosophy. I. Title.
N66.D26 2013
700.1—dc23 2012031606

ISBN 978-0-300-20571-8 (pbk.)

A catalogue record for this book is available from the
British Library.

10 9 8 7 6 5 4 3 2

For Lydia Goehr

CONTENTS

It is widely accepted that Plato defined art as imitation, though whether this was a theory or merely an observation is difficult to say, since there was nothing else by way of art in Athens in his time. All that seems clear is that imitation in Plato meant pretty much what it means in English: looks like the real thing but isn't the real thing. But Plato was mainly negatively interested in art, since he was attempting to design an ideal society—a Republic!—and was eager to get rid of the artists on the grounds that art was of minimal practical use. In order to achieve this goal, he drew up a map of human knowledge, placing art at the lowest possible level—with reflections, shadows, dreams, and illusions. These Plato regarded as mere appearances, a category to which belonged the kinds of things an artist knew

how to make. Thus artists could draw a table, meaning that they knew how tables appear. But could they actually make a table? Not likely—but what good really was the appearance of a table? In fact, there was a conflict between art and philosophy, in that the writings of poets were used for teaching children how to behave. Plato felt that moral pedagogy should be left to philosophers, who used not imitations but reality in explaining the way things are.

In Book Ten of *The Republic*, Plato's character—Socrates— suggested that if you want to imitate, nothing could be better for that than a mirror, which will give you perfect reflections of whatever you aim the mirror at, and better than an artist can usually achieve. So let's get rid of the artists. The Greeks used texts like *The Iliad* pedagogically, to teach right conduct. But philosophers know the highest things, what Plato called ideas. Once the artists were out of the way, philosophers could teach and serve as rulers not susceptible to corruption.

In any case, no one can deny that art as practiced consisted in imitations or capturing appearances, to paraphrase modern art historians. How different from the present situation! "I am very interested in how one approaches that topic—What is Art," writes my friend the artist Tom Rose in a personal note. "The question that comes up in every class and in every context." It is as if imitation disappeared, and something else took its place. In the eighteenth century, when aesthetics was invented or discovered, the thought was that art contributed beauty, hence gave pleasure to those with taste. Beauty, pleasure, and taste were an attractive triad, taken seriously by Kant in the early pages of his masterpiece, *The Critique of Judgment*. After Kant—and Hume

before him—there were Hegel, Nietzsche, Heidegger, Merleau-Ponty, and John Dewey, each delivering marvelous but conflicting theses. And then there were the artists themselves, with paintings and sculptures to sell in galleries and art fairs and biennials. Small wonder the question of what is art came up "in every class and every context." So—what is art? What we know from the cacophony of artistic argument is that there is too much art that is nonimitational for us to read Plato except for the sake of his views. This was a first step. It was Aristotle who carried it much further, by applying it to dramatic presentations—tragedies and comedies—which he argued were imitations of actions. Antigone was the model of a wife, Socrates was not quite the model of a husband, and so on.

My thought is that if some art is imitation and some art is not, neither term belongs to the *definition* of art as philosophically understood. A property is part of the definition only if it belongs to every work of art there is. With the advent of Modernism, art backed away from mirror images, or, better, photography set the standard of fidelity. Its advantage over mirror images is that it is able to preserve images, though of course photographic images are liable to fade.

There are degrees of fidelity in imitation, so Plato's definition of art remained in place, with little to argue about until it stopped capturing the seeming essence of art. How could this have happened? Historically it happened with the advent of Modernism, so this book begins with certain revolutionary changes that took place in France, mainly in Paris. Plato had had an easy run, from the sixth century BC until AD 1905–7, with the so-called Fauves—Wild Beasts—and Cubism. In my view, to get a definition better than Plato's you have to look to more recent artists, since they are

most likely to subtract from their theories properties that were earlier thought to be essential to art, like beauty. Marcel Duchamp found a way of eradicating beauty in 1915, and Andy Warhol discovered that a work of art could exactly resemble a real thing in 1964, though the great movements of the 1960s—Fluxus, Pop Art, Minimalism, and Conceptual Art—made art that was not exactly imitation. Oddly, sculpture and photography shifted the center of artistic self-awareness in the seventies. After that, everything was feasible. Anything went, leaving it uncertain whether a definition of art is any longer possible. Anything cannot be art.

The first and longest chapter may feel like art history, but it is not. It was basically decided by leading aestheticians that art was indefinable, since there is no overarching feature. At best, art is an open concept. My view is that it has to be a closed concept. There must be some overarching properties that explain why art in some form is universal.

It is true that art today is pluralistic. Pluralism was noticed by certain followers of Ludwig Wittgenstein. What makes art so powerful a force as it appears to be in song and story is due to what makes it art to begin with. There is really nothing like it when it comes to stirring the spirit.

I have tried, using Duchamp and Warhol to achieve my definition of art, to outline examples from the history of art to show that the definition always has been the same. Thus I use Jacques-Louis David, Piero della Francesca, and Michelangelo's great ceiling for the Sistine Chapel. If one believes that art is all of a piece, one needs to show that what makes it so is to be found throughout its history.

WHAT ART IS

WAKEFUL DREAMS

arly in the twentieth century, beginning in France, the visual arts were revolutionized. Up until that point, they—which, unless otherwise indicated, I shall simply designate *art*—had been dedicated to copying visual appearances in various media. As it turned out, that project had a progressive history, which began in Italy, in the time of Giotto and Cimabue, and culminated in the Victorian era, when visual artists were able to achieve an ideal mode of representation, which the Renaissance artist Leon Battista Alberti, in his *On Painting,* defined as follows: there should be no visual difference between looking at a painting or looking out a window at what the painting shows. Thus a successful portrait should be indiscernible from seeing the subject of the portrait looking at us through a window.

This was not possible at first. Giotto's paintings may have dazzled his contemporaries, but, to use an example from the art historian Ernst Gombrich's *Art and Illusion,* Giotto's pictures would be considered crude in comparison with the image of a bowl of cornflakes made with an airbrush by a commercial artist of today. Between the two representations lay a number of discoveries: perspective, chiaroscuro (the study of light and shadow), and physiognomy—the study of achieving naturalistic representations of human features expressing feelings appropriate to their situation. When Cindy Sherman visited an exhibition of the work of Nadar, the French photographer of the nineteenth century, showing actual people expressing different feelings, she said: they all look alike. Context often tells us what someone's feelings are: horror in a battle scene could express hilarity at the Folies Bergère.

There were limits to what art—composed of such genres as portraiture, landscape, still life, and historical painting (the latter of which, in royal academies, enjoyed the highest esteem)—could do to show movement. One could see *that* someone moved, but one could not actually see the person move. Photography, which was invented in the 1830s, was considered by one of its inventors, Englishman William Henry Fox Talbot, to be an art, as is implied by his expression "the Pencil of Nature," as though nature portrayed itself by means of light, interacting with some photosensitive surface. Light was a far better artist than Fox Talbot, who liked to bring home pictures of what he saw. Using a bank of cameras with trip wires, Eadweard Muybridge, an Englishman

who lived in California, photographed a horse trotting in front of them, producing a series of stills that showed stages of its motion, settling the question of whether horses in motion ever touched ground with all four hooves at once. He published a book called *Animal Locomotion* that included similar photographs of moving animals, humans included. Because the camera could reveal things that were invisible to the unaided eye, it was deemed more true to nature than our visual system. And for this reason photography was regarded by many artists as showing how things would actually appear if our eyes were sharper than they are. But Muybridge's images, like what we often see in contact sheets, are frequently unrecognizable because the subject has not had the time it takes to compose his or her features into a familiar expression. It was only with the advent of the cinematographic camera, in which strips of film moved with mechanical regularity, that something like motion could be seen when the film was projected. Using that invention, the Lumière brothers made genuine moving pictures, which they screened in 1895. The new technology represented men and animals in movement, seen more or less the way the spectator would actually see it, without having to infer the motion. Needless to say, many may have found cloying the scenes that the Lumières shot, such as workers streaming out of the brothers' factory, which may have been why one of the Lumières concluded that moving pictures had no future. Of course, the advent of the narrative film proved the opposite.

In any case, the moving picture united with the literary arts, ultimately by means of sound. In adding sound to motion, mov-

ing pictures had two features that painting could not emulate, and thus the progress of visual art as the history of painting and sculpture came to a halt, leaving artists who hoped to take the progress of painting further with no place to go. It was the end of art as it was understood before 1895. But in fact painting entered a glorious phase when it was revolutionized a decade after the Lumières' moving picture show. For philosophers, Alberti's criterion ended its reign, which somewhat justifies the political overtones of "revolution."

Let us now move to a paradigm of a revolutionary painting—Picasso's *Les Demoiselles d'Avignon*, executed in 1907 but which remained in the artist's studio for the next twenty years. Today it is a very familiar work, but in 1907 it was as if art had begun all over again. It in no sense aimed at taking a further step toward fulfilling Alberti's criterion. People may well have said that it was not art, but that would usually mean that it did not belong to the history that Giotto opened up. That history had more or less excluded as art some of the greatest artistic practices—Chinese and Japanese painting were exceptions, though they did not exactly fit the historical progress. Their system of perspective, for example, seemed visually wrong. But Polynesian, African, and many more forms of art were beyond the pale and today can be seen in what are called "encyclopedic museums" like the Metropolitan Museum or the National Gallery in Washington. In Victorian times, works from these various other traditions were designated as "primitive," meaning their work corresponded to the level of very

early European work, like the Sienese primitives. The thought was that such work would be art in the sense of copying visual reality with exactitude, provided those creating the works were able to visualize doing it. In the nineteenth century, works from many of these traditions were displayed in museums of natural history, as in New York or Vienna or Berlin, and studied by anthropologists rather than art historians.

Still, it was art and, as such, has considerable importance for this book, which means to analyze the concept of art in a sense far wider than my initial use of the term. The huge differences between the art that belongs to what we might as well call Albertian history and most of the art that does not mean that the pursuit of visual truth is not part of the *definition* of art. Art may well be one of the great achievements of *Western* civilization, which means that it is the defining mark of the art that began in Italy and was furthered in Germany, France, the Netherlands, and elsewhere, including America. But it is not the mark of art *as such*. Only that which belongs to all of art belongs to art as Art. When they see work that puzzles them, people ask, "But is it art?" At this point I have to say that there is a difference between *being* art and knowing whether something *is* art. Ontology is the study of what it means to be something. But knowing whether something is art belongs to epistemology—the theory of knowledge—though in the study of art it is called connoisseurship. This book is intended mostly to contribute to the ontology of Art, capitalizing the term that it applies to widely—really to everything that members of the

art world deem worthy of being shown and studied in the great encyclopedic museums.

Most veterans of Art History 101 will have carried away the information that Picasso's *Demoiselles* is an early Cubist master-piece, whose subject is five prostitutes in a well-known Barcelona bordello named after Avignon Street, where it was situated. Its size—eight feet by seven feet eight inches—is on the scale of a battle painting, which implies a revolutionary declaration, flaunt-ing its message. No one could suppose that the women really looked the way Picasso painted them. A photograph of the quintet would make it plain that Picasso was not interested in copying vi-sual appearances, but the image has its realisms. The scene takes place in the bordello's salon, where two of the women lift their arms to display their charms to clients. There is a bowl of fruit on the table, emblematizing that the scene is indoors.

The painting features three types of women, shown in differ-ent styles. It would be impossible to see through a window what the painting shows. The two women with raised arms are painted in a style developed by the Fauves, whom I describe below. Their facial features are outlined in black, and their eyes are exagger-ated. To the viewer's right of these women are two other women, one whose face is covered by an African mask and another with a head that belongs to effigies of African goddesses. One of them squats. On the left side of the canvas is an attractive woman, about to enter the space, if the two central figures fail to attract. Read-ing from right to left, Picasso has painted an evolution of women

from savages, to Fauve-like flirts, to an attractive woman of the kind he painted in his Rose period. The two beckoning women are bathed in light, as if from a floodlight shining down on them, and this divides the scene into three vertical areas; the one to the right is a kind of curtain composed of Cubist fragments, the one to the left is straight up and down, like the wing of a stage, giving the space a theatrical feeling. The sequence of female bodies— and heads!—is like a Freudian scheme of id, ego, and superego. If he had been compelled to respond to criticism that the women don't really look the way the painting shows them, Picasso might have said that he was interested not in appearance but in reality. The Africanesque pair are savage, fierce, aggressive. The middle pair are seductive, willowy whores. Entering the stage from the left is a Parisian girl with regular features. From the perspective of traditional painting, there is a stylistic incoherence. Picasso needed this incoherence between the three kinds of female to represent three psychological strata, or three stages in the physical evolution of women. Both the psychological triad and the evolutionary one have a bordello as their setting. If someone asks what the painting is about, the right answer would probably be women, as Picasso believes they really are. They are destined for sex. Picasso's art is a battle against appearances, and hence against the progressive history of art. The *Demoiselles* are painted in a new way to bring out the truth about women as Picasso saw it.

A second revolutionary mood is to be found in 1905, at the Autumn Salon, held in the Grand Palais in Paris. One of the galleries particularly aroused hostility, harsh enough to explain why

Picasso kept his masterpiece from public exhibition. The subjects were part of everyone's world—sailboats, bouquets, landscapes, portraits, picnics. But these were not shown *as they look to ordinary vision*. A critic at the time described the works in this gallery as "a Donatello surrounded by wild beasts [*Fauves*]." The critic, Louis Vauxcelles, was expressing the term ironically, as he did when he described Picasso and Georges Braques as "Cubists," which was not in the dictionary of the time. "Wild Beasts" fit the paintings relatively to those made in the later progressive history in terms of Alberti's criterion, even if the subject was terrifying, like a painting by Paul Delaroche of Lady Jane Grey, blindfolded, feeling about for the chopping block on which she was to be beheaded. It was the artists that were "Wild Beasts," not what they painted, which was gentle enough.

One cannot but praise the curator who arranged this striking juxtaposition. Donatello was a Renaissance master, in this case surrounded by the work of artists who the public thought did not know how to paint or carve. They used bright colors, in all likelihood squeezed directly from paint tubes, edged by often heavy black lines: Picasso's two pink Demoiselles, outlined in black and with eyes wide open like early Spanish sculptures, show the spirit of Fauvism. Two of the Wild Beasts were Henri Matisse and André Derain. And whether the artists there appreciated it or not, the strategy of showing works that were marked by the same extravagant style—the wilder the better—implied that something new was happening in the art world. All the better if visitors jeered and laughed, since that authenticated the art as revolutionary. There was a tradition for that. Because of the unusually severe judges who excluded

a great many works from the Salon of 1863, the emperor, Louis-Napoléon, proposed a *Salon des refusés* in which artists excluded from the main event could exhibit their works if they wished. The Parisians, true to type, laughed themselves silly at the paintings, including Manet's *Olympia,* which showed a well-known prostitute, Victorine Meurant, naked and beautiful, with dirty feet and a ribbon around her neck, glaring, as it were, at the merrymakers while being waited on by a black servant bearing flowers, doubtless sent by a patron. Claude Monet later organized a body of admirers who purchased *Olympia,* which survived as a national treasure.

An important purchase from the 1905 exhibition, *Woman with a Hat,* by Matisse, was acquired by the American collector Leo Stein—not Gertrude(!)—who had originally been among those who felt that Matisse did not know how to paint. Leo recorded his first impression of *Woman with a Hat:* "Brilliant and powerful, but the nastiest smear of paint I had ever seen." It was, John Cauman writes, the first purchase of a Matisse by an American. The model was Matisse's wife, and he must have wanted to make visible her character as a particularly strong and independent woman. Once more it is clear that the artist did not paint her the way she would look if photographed but rather as she was, providing one interpretation of what is going on in the painting. Matisse painted her with certain character traits, rather than visual traits. So the painting had to express his admiration, which leaves it to us to understand what he meant by what we see. My sense is that the extraordinary hat shows her character. A woman who wears a hat like that draws attention to herself, and this is reinforced by the play of colors on her dress, which is radically

different from the standard black dress bourgeois women wore. And the background consists of a collection of brushy patches of colors that reflect the dress. He paints her not in a room or a garden, but against a background of controversial patches of paint borrowed from Cézanne. Responding as they did to any art that deviated from the Albertian standards, the French public howled with laughter at the way Matisse represented his wife. But he was, in the end, human, and he had begun to doubt his gifts. The acceptance by the Steins restored his confidence. Sales at art exhibitions are never merely an exchange of art for cash. Especially in early Modernist time, money emblematized the victory by art over laughter, which was intended to defeat the purchased art.

I would like to pause here to cite an excerpt from "The Man with the Blue Guitar," by the American poet Wallace Stevens, who clearly understood the paintings we have been analyzing.

> They said, "You have a blue guitar,
> You do not play things as they are."
>
> The man replied, "Things as they are
> Are changed upon the blue guitar."
>
> And they said then, "But play, you must,
> A tune beyond us, yet ourselves,
>
> A tune upon the blue guitar
> Of things exactly as they are."

But that in effect is what the early Modernists did.

In 1910 the American Arthur Dove began to make abstract paintings, along with the Suprematist Malevich, who painted his *Black Square* in 1915, as abstraction appealed to avant-garde painters of Early Modernism as well as later to painters of High Modernism, in the so-called New York School—also known as Abstract Expressionism—in the forties and fifties.

Up until the advent of abstraction, paintings were also pictures. For a long time, the two terms were interchangeable. The critic Clement Greenberg, for example, spoke of Abstract Expressionist works as "pictures," as though a painting had to be a picture, even if abstract, raising the question of what its subject could be, since it really did not look like any recognizable object. The usual move was to say that the artist painted his feelings, rather than something visible. In a famous article Greenberg's rival critic Harold Rosenberg contended that what abstract painters did was perform an action on a canvas, the way a bullfighter performs an action in the ring. This explained, in a way, the excitement of Jackson Pollock's flung painting, thrown from a stick or a brush, or Willem de Kooning's distinctive heavy brushstrokes, which often combined to form a figure, as in his celebrated *Woman* paintings of 1953. But such was the state of criticism at the time that Rosenberg's theory was felled by quips like "Who ever hung an action on a wall?" The brushwork of the painters Rosenberg had in mind represented traces of action, the way a skid mark is a trace of a skid.

Two concepts of abstraction existed in New York in the 1940s. The European sense of abstraction was this: the artist abstracts

from visual reality so that there is a path, so to speak, from the surface of the painting to the real world, different from the traditional path, where the surface of the painting "matched" what one might call the surface of reality. This derives from the Renaissance tradition discussed earlier, that looking at a picture was like looking through a window onto the world. It was as if the artist reproduced on the panel or canvas surface the same array of visual stimuli that would affect the eye if one were looking through a transparent surface at the subject of the picture. Abstraction broke this connection. The surface of the painting resembled only abstractly what the subject matter of the painting would show. But still, there was a path from subject to painting, which explains why everyone continued to speak of abstractions as "pictures." A famous and influential sequence of paintings by Theo van Doesburg shows the stages by which Cubism goes from a straightforward picture of a cow to an abstraction of the same subject matter, which does not in the least look like a cow. Had Pasiphaë, who lusted after the Minotaur and disguised herself as a beautiful cow, looked like van Doesberg's final canvas, no bull in the world would have perceived her as a sexy heifer. There was no obvious resemblance between cow and painting, as there was none between the first and final picture in the series. But van Doesburg's point was that abstract art must begin with nature—with objective visual reality. At the time, the path of abstraction was one or another form of geometrization, which almost meant Modern. The major protagonist of natural abstraction was the artist and teacher Hans Hofmann, who ran a successful school in

Greenwich Village and, in the summer, in Provincetown on Cape Cod. When Hofmann said to Jackson Pollock that abstraction comes from nature, Pollock responded, "I am Nature." But this rested on the theory of autonomism as used by the Surrealists. The mind, even the unconscious mind, was part of nature.

Hofmann was skeptical about Surrealism, which insisted on *sur*-reality. Sur-reality was a kind of psychology of reality, *hidden* from the conscious mind, and it was on this psychological reality that the Surrealists felt true art is finally based. It is based on nature, which can be penetrated to reveal its psychic basis. In the case of an individual, his or her psychic reality is what the Freudians term the "unconscious system." One main path to the unconscious system is through dreams—the "royal road to the unconscious," according to Freud. Another avenue to the unconscious is through automatic writing or automatic drawing—what Robert Motherwell domesticated under the name "doodling." For American abstraction, as against European abstraction, the path was not geometry but spontaneity, where conscious control was suspended. Automatic drawing or writing connected the artist to his or her inner self.

During the Second World War, the Surrealists were in exile in New York, and they had an immense impact on New York's artists, who were dazzled by André Breton and able to meet truly famous artists like Salvador Dalí.

In his first Surrealist Manifesto of 1924, Breton defined Surrealism methodologically. It was "pure psychic automatism by which one intends to express verbally, in writing or by other

method, the real functioning of the mind. Dictation by thought, in the absence of any control exercised by reason, and beyond any aesthetic or moral preoccupation." It is important to stress that Breton saw the unconscious from an epistemological perspective: it was like a cognitive organ which disclosed a world with which we have lost contact—a marvelous world which appears to us in dreams and to which automatic writing and drawing give us access. It is, that is, not simply to the unconscious mind that automatism takes us, but through that mind to the world with which it is in contact, past the real to the sur-real. That world, through the mediation of the unconscious, speaks through the medium of automatic writing. To practice automatism means to disengage reason, calculation, and indeed everything component in "the highest cerebral centers," to cite a useful expression. And since Breton found it imperative to identify automatism with art, the art he favored was an unpremeditated and uncontrolled pouring forth of language, without guidance or censorship—a kind of "speaking in tongues" which was, for the Spiritualist mouthpiece, the persona of the Holy Spirit. It is little wonder that the early Abstract Expressionists, who were profoundly affected by the tone of Surrealist thought if not its substance, should have seen themselves as shamans through whom objective forces poured forth.

But the Surrealist who was closest to the New Yorkers was Roberto Matta, an architect and artist from Chile who held a class in automatic drawing. Among those who participated in it were Robert Motherwell, Arshile Gorky, and even Jackson Pollock. Motherwell did not admire Matta greatly as a painter—"For me

[his paintings] were theatrical and glossy, too illusionistic for my taste"—but he thought highly of his colored pencil drawings: "His painting never compared to his drawings." And drawing lends itself to "doodling" rather more readily than painting does: or painting has to be reinvented, so to speak, in order to make room for painterly doodles. (Dalí could make a splendid painting of a doodle, but it is difficult to picture him doodling as such.) "The fundamental principle that he and I continually discussed, for his palace revolution, and for my search for an original creative principle," Motherwell wrote in a 1978 letter to Edward Henning. "What the surrealists called psychic automatism, what a Freudian would call free-association, in the specific form of doodling."

The "original creative principle," Motherwell said more than once, was "the thing lacking in American Modernism." It was to be something which, once discovered, would enable American artists to produce original Modernist works, by contrast with what was the practice at the time, which involved the attempt to be Modernist by emulating European works which were by definition Modernist. And it was in formulating this that Motherwell's philosophical training and sensibility comes through. "The American problem," he emphasized in his discussion with Barbaralee Diamonstein, "is to find a creative principle that was not a style, not stylistic, not an imposed aesthetic." He formulated this as a problem, on at least two occasions, with Gorky specifically in mind. In his interview with Diamonstein, he said: "The enormously gifted Gorky had gone through a Cézannesque period and was, for the 1940s, in a passé Picasso period, whereas much

lesser European talents were more in their own 'voice,' so to speak, because they were closer to the living roots of international Modernism (in fact, it was through the Surrealists and, above all, personal contacts with Matta that Gorky shortly after would take off like a rocket)."

Motherwell said that Matta "shifted Gorky from copying *Cahiers d'art*—a European journal something like *Artforum* is today—to a full-blown development of his own." So Gorky was the model of what the original creative principle could do. "With such a creative principle, modernist American artists could cease to be mannerists," Motherwell told Henning. It transformed Gorky, realizing his native gift, from a mannerist of Modernist idioms to the original artist he became (alas, he lost his wife to Matta in exchange and committed suicide). Psychic automatism was an almost magical device for enabling each person to be at once artistically authentic to his or her true self, and at the same time modern. "And," Motherwell noted, "what was 'American' would take care of itself as it did soon enough."

Early in his marriage to an American girl, Agnes Magruder, Gorky accompanied her and their children to her parents' summer home in Virginia in 1946. There he was gripped by the similarity between the flowers in the meadows around the house and those he remembered from his homeland in Turkey, from which he and his mother were forced to flee for religious reasons. As an artist, he was first slavishly dedicated to the School of Paris, and particularly to Picasso. "If Picasso drips, I drip." But he drew and painted the fields that so moved him through their similar-

ity to those in his homeland. So in a way, his "original creative principle" was Turkish American, just as Motherwell said. Gorky became an early member of the New York School.

In 1912 Marcel Duchamp's brothers, members of a group of Cubists that took seriously the mathematics the movement celebrated, pressed him to withdraw a painting from a Cubist show in Paris, because it did not fit in. That painting—*Nude Descending a Staircase, No. 2*—was exhibited in New York in the Armory show in 1913, and made him famous in America. The problem was that Duchamp used Cubist tactics to convey the movement of the nude down a staircase, which contaminated pure Cubism. The overlapping Cubist planes introduced movement into the picture. But movement, and especially speed, was the central mark of Futurism, hence the doctrinaire compelling Cubists to zealously guard the movement's boundaries. In America, critics were delighted by the overlapping planes, which were wittily described as an "explosion in a shingle factory." Together with Brancusi's *Mademoiselle Pogany,* the two works gave America its first glimpse of Modernism. While jokey, American laughter was nevertheless quite different from French laughter, its main weapon against artistic innovation.

There were many artistic movements, beginning with Cubism and Fauvism, down the years, each with a distinctive style, often with a manifesto of the social and political benefits that the movement endorsed. Futurism supported Fascism in pictures and architecture, and Social Realism of course celebrated labor, indus-

trial and agricultural, as the hammer and sickle projected, though there were voices in Russia that supported Cubo-Futurism as the future of art. The Alberti criterion went from being what art was to a movement like the rest, now identified as Realism, which boasted masters such as Edward Hopper, who picketed the Whitney Museum because he believed its curators were prejudiced in favor of abstraction. New York in the thirties had many Communist or at least Marxist artists whose work Gorky stigmatized as "poor painting for poor people." Scholars have identified upward of five hundred manifestos, though not every movement produced one. There is, for example, no Fauve manifesto. Following Cubism and Fauvism, there was Surrealism, Dada, Suprematism, Geometric Abstraction, Abstract Expressionism, Gutai in Japan, color-field painting (supported by Greenberg), Pop Art, Minimalism, and Conceptual Art in the sixties, Irwin in Slovenia and Appropriationism in SoHo, and then the Young British artists in England, led by Damien Hirst, and many, many more.

While most of these abandoned the strict Albertian format of pictures matching how things really look just outside the window, and were not interested in adding to the progression taken for granted in the nineteenth century, there was a continuity of media—oil paint, watercolor, acrylic (once it was invented), pastel—and then clay for modeling, plaster for molding, bronze for casting, and wood for sculpture carving. And then the various print media involving woodblocks, copper plates, and lithographic stones.

The one major change that characterized the seventies and

that has lingered into the present was that many artists turned away from the traditional "artists' materials" and began to put to use anything whatever, but especially objects and substances from what phenomenologists spoke of as the *Lebenswelt*—the ordinary daily world in which we live our lives. That raises a central question of contemporary philosophy of art, namely, how to distinguish between art and real things that are not art but that could very well have been used as works of art.

This struck me one day when I had agreed to meet with some art students—or perhaps they were philosophy students—to hold an informal seminar at Berkeley. When I entered the building, I walked past a large classroom which was being painted. The room contained ladders, drop cloths, cans of wall paint and turpentine, and brushes and rollers. I suddenly thought: what if this is an installation titled *Paint Job?* The Swiss artist duo Fischli and Weiss in fact made an installation in the vitrine of a shop on a main street in a town in Switzerland—perhaps Zurich—that consisted of ladders, paint cans, paint-splashed drop cloths, and the like. People who knew about Fischli and Weiss came to see it as a cultural object. But what interest would it have for art lovers if it was, instead of art, merely a paint job (not capitalized)?

In the seventies, the German guru Joseph Beuys—who taught at Düsseldorf—declared that anything could be art. His work supported this claim, since it made art out of fat—when he was given an exhibition at the Guggenheim Museum, there was, in the atrium, a lump of fat the size of a small iceberg. His other signature material was felt blankets. The explanation—or legend—of

what these two materials meant to him corresponded to a plane crash he experienced in Crimea while a fighter pilot during World War II. He was found by a group of natives, who nursed him back to health by slathering him with animal fat and wrapping him in felt blankets. These accordingly became tokens fraught with meaning—far more than oil paint could possibly have, as warmth is a universal human need.

Robert Rauschenberg wrote in the catalog of *Sixteen Americans* at the Museum of Modern Art in 1955 that "a pair of socks is no less suitable to make a painting with than wood, nails, turpentine, oil and fabric." He used a quilt, Coca-Cola bottles, automobile tires, and stuffed animals in his art. Bringing reality into art, when reality had been what art was to represent, changed the way people thought of art. It brings us to the substance of the question of "what art is" today. But there are issues I need to address before I can take on that question philosophically.

The first artist I need to discuss is the composer John Cage, who raised the question of why musical sounds are limited to the conventional notes on scales. The auditory world is filled with sounds that play no role in musical composition. He raised this question in a work played by the pianist David Tudor on August 29, 1952, in Woodstock, New York.

The piece is called "4'33,"" which is the performance time Cage designated for it. It consisted of three movements of different lengths. Tudor signaled the beginning by covering the keyboard with the keyboard cover, and then he measured the length

of the movement with a stopwatch. At the end of the movement, he raised the keyboard cover. He then did the same thing a second time, and a third. He did not play a note, but when he was finished he took a bow. Cage used as many score sheets as he thought were needed. It is often proposed that Cage was teaching his audience to listen to silence, but that was not his intention. Rather, he wanted to teach his audience to listen to the sounds of life—barking dogs, crying babies, thunder and lightning, the wind in the trees, motor vehicle backfires and putt-putt noises. Why can these not be music? Woodstock is not Paris, but the audience might as well have been Parisians. They walked out in droves. The murmured judgment was that "Cage had gone too far."

Cage had taught at Black Mountain College, where he met the great dancer Merce Cunningham and Rauschenberg. The three of them were involved in an early avant-garde work, *Theater Piece*, and influenced one another profoundly. Rauschenberg painted an all white canvas, which Cage described as a "landing field," with lights and shadows—or houseflies—being part of it. In truth, the white painting inspired the concept of a silent piece of music, where the vernacular noises became part of it. The noises became part of the music.

The use of such items as those that Rauschenberg incorporated into his work brought reality into art in the early fifties. Plus, of course, the slathered paint, as in Rauschenberg's *Bed*, which connected Rauschenberg's work with that of the New York School. Jasper Johns used targets, numerals, and flags because, as

I see it, a picture of a flag is a flag, a numeral is a number, and a painting of a target is a target, so the object is ambiguous between art and reality. And Cy Twombly, at least in the early years, took the substance of scribbles as his subject.

Sometime in the seventies, the social configuration of the art world changed. Organizations sprang up that sought to identify emerging artists, who were given one-person shows by leading galleries, and whose work was collected as investments. For the most part, movements disappeared as the wave of the future, and the search for emerging talent took its place. By the end of the seventies, when the artist Robert Rahway Zakanitch, whose work represented domestic spaces and objects, wanted to start a movement to oppose the prevailing Minimalist aesthetic, he had to ask people how one started a movement. There were enough artists sympathetic with his ideas that Pattern and Decoration—P&D—was formed. It was, in my view, pretty much the last significant movement, at least in America.

I recall how New Yorkers expected to learn from the Whitney Biennials the direction in which art was headed. For years Greenberg was the authority on this. But by 1984 the reign of Greenberg was largely over. Instead of art movements, political movements like feminism began to demand space to show its work. Multiculturalism was less a movement than a curatorial decision to feature the art of blacks, Asians, American Indians, and gays of either sex. The Biennial of 1983—the year before I became an art critic—made me feel that the work displayed was not, to

paraphrase the art world expression, what was supposed to happen next, which then raised the question of what was to happen instead. The "next big thing" seemed suddenly not expected, and the artistic corps consisted of a large pool of talented individuals, emerging or emerged, looked over by increasingly powerful curators who promoted their tastes and commitments.

The issue of what art is has become a very different matter than it has been in any previous moment in history. That is because, especially in the late twentieth century, art had begun to reveal its inner truth. It is as though the history of art, after centuries of progress, finally began to disclose its nature. In Hegel's masterpiece, *The Phenomenology of Spirit,* "Spirit" finally finds what it is at the end of its search. Art, in his philosophy, is a component of Spirit, together with philosophy and religion. In a way, my analysis to this point has something in it of the *Phänomenologie des Geistes,* to use the book's German title. I have tried to trace the history of modern art with giant steps to a point at which I can finally address the question itself. There was something in the way art was thought of that answered the question of what it itself is.

I want to analyze in some degree the two major artists who, to my mind, made the greatest contribution to the issue—Marcel Duchamp in 1915 and Andy Warhol in 1964. Both of them were connected with movements, Dada in the case of Duchamp, and Pop Art in connection with Warhol. Each movement was to some degree philosophical, removing from the concept of art conditions

which had been thought to be an inseparable part of what art was. Duchamp, as a Dadaist, tried as a matter of Dada principle to forebear producing beautiful art. He did so for political reasons. This was an attack on the bourgeoisie, whom Dada held responsible for the Great War, which many members of the movement sat out in Zurich or, in Duchamp's case, in New York from 1915 to 1917, when America entered the war. Drawing a moustache on a postcard of Mona Lisa "uglified" the famous portrait of a beautiful woman. In 1912—the year in which he was pressured to withdraw *Nude Descending a Staircase, No. 2* from a Cubist exhibition— Duchamp attended an aeronautical show just outside Paris, with the painter Fernand Léger and the sculptor Constantin Brancusi. According to *Marcel Duchamp: Artist of the Century,* among many sources, the artists found themselves in the presence of a great wooden airplane propeller. Duchamp said, "Painting is washed up," adding, pointing to the propeller, "Who'll do anything better than that propeller? Tell me, can you do that?" Perhaps the propeller stood for speed, which the Futurist painters—and Duchamp himself—thought a mark of modernity. Or perhaps it conveyed flight, which was fairly novel. Or perhaps power. The episode was not further commented on. It was an early statement in which a piece of machinery was compared or contrasted with works of art.

The propeller in any case was not, and could not have been, an example of what Duchamp called "readymades"—an expression that he saw in the window of a dress shop, where it contrasted with "made to order." This was in 1915, when he sailed into New York harbor a famous man, thanks to *Nude Descending a Staircase,*

No. 2. In interviews with the press he seemed to say that painting was European, and that European art as a whole was "washed up." To the reporters he said, "If only America would realize that the art of Europe is finished—dead—and that America is the country of the art of the future, instead of trying to base everything she does on European tradition. . . . Look at the skyscrapers!" He later added bridges and, notoriously, American plumbing.

Also in 1915 Duchamp purchased a snow shovel in a hardware store on Columbus Avenue, which he carried over his shoulder to the apartment of his patron, Walter Arensberg. He gave it the title "In advance of the broken arm," which he carefully lettered on the shovel's handle. Many years later, he stated, in "Apropos of 'Readymades'"—a talk he gave at the Museum of Modern Art in New York—that "a point I want very much to establish is that the choice of these 'readymades' was not dictated by aesthetic delectation. This choice was based on a reaction of visual indifference with at the same time a total absence of good or bad taste . . . in fact a complete anaesthesia." Duchamp had a deep distaste for what he called "retinal art"—art that gratified the eye. He felt that most art since Courbet was retinal. But there were other kinds of art—religious art, philosophical art—which were far less concerned with pleasing the eye than with deepening the way we think.

Notice the date: 1915. It was the second year of the First World War—"the war to end wars"—and Duchamp was doing his Dadaist bit by abusing beauty. But in attacking "taste" he was calling into question the central concept of aesthetic theory for such

philosophical writers as Immanuel Kant, David Hume, and the artist William Hogarth. Beyond that, all twenty of the readymades that Duchamp created took objects out of the Lebenswelt and elevated them to works of art, which subtracted from the concept of art everything having to do with craftsmanship and touch and, above all, the artist's eye. Finally, there was more to the abuse of beauty than simply the Dada decision to punish the bourgeoisie for its decision to go to war, consigning to their death millions of young men on the battlefields of Europe. So the readymade was by far more than a joke. Small wonder that Duchamp said, "I'm not at all sure that the concept of the readymade isn't the most important single idea to come out of my work." It certainly entailed problems for philosophers like myself concerned with defining art. Where are the boundaries of art? What distinguishes art from anything else, if anything can be art? We are left with the not very consoling idea that just because anything *can be* art, it doesn't follow that everything *is* art. Duchamp managed to condemn pretty much the entire history of aesthetics, from Plato to the present.

The most famous readymade is a urinal, lying on its back and crudely signed with the false signature "R. Mutt 1917," splashed onto the urinal's rim. That was the year when America entered the war and Alfred Stieglitz's 291 gallery (so-named because it was located at 291 Fifth Avenue in New York) closed shop. Duchamp had submitted it to the exhibition sponsored by the Society of Independent Artists, mainly, one feels, to put pressure on the organization, whose policy was that anything would be shown if the artist paid the admission fee, and that there were

to be no prizes. This in fact was the policy of the French Society of Independent Artists, whose members need not have been members of the Academy of Fine Art. As is widely known, the Society managed to reject *Fountain,* as Duchamp ironically named it. The chairman of the committee justified the action by saying that any piece of art would be accepted—but a urinal is a piece of plumbing, not a work of art.

The 291 gallery was the leading such institution dedicated to Modern art, displaying the work of such artists as John Marin, Marsden Hartley, Charles Demuth, and Stieglitz's wife, Georgia O'Keeffe. Stieglitz himself was an artist, since, if any photographs are works of art, his photographs are. But photography as art was highly contested in those years, so perhaps for that reason Duchamp's sponsors carried the readymade to 291 to be photographed by Stieglitz, who did so in rich sepia, as a work of art, placed as a sculpture just under a painting by Marsden Hartley. It can be recognized as a flat-back Bedfordshire urinal that Duchamp is said to have spotted in the window of a plumbing supply store. The mystery is that this model, purported to be manufactured by the Mott Iron Works (cf. *Mutt* Iron Works), appears to have vanished from the face of the Earth. Not even the Museum of Modern Art was able to find one for a major exhibition of Duchamp's work. But at least we know what it looked like. Lying on its back, with the drain holes at it base, it is very much like a woman assuming the bottom partner in the missionary position, even if the urinal is designed for the comfort of the male. Duchamp never avoided a sexual touch, if he could find one. His oeuvre is philosophi-

cally rich, particularly in its attitude to beauty, which for centuries was believed internal to the concept of art. After all, most of the institutions that graduated artists since the seventeenth century had the word "beautiful" in their title: *beaux arts, bellas artes,* and the like. That something could be art but not beautiful is one of the great philosophical contributions of the twentieth century. Arensberg sought to defend Duchamp at the meeting where it was decided not to accept "Mr. Mutt's" urinal: "A lovely form has been revealed, freed from its functional purpose, therefore a man clearly has made an aesthetic contribution." In truth, Duchamp's contribution was to have made a work of art minus aesthetics. He contributed "The Richard Mutt Case" to *The Blind Man,* an ephemeral publication published in conjunction with "The Blind Man's Ball": Whether Mr. Mutt, with his own hands made the fountain or not has no importance. He CHOSE it. He took an ordinary article of life, placed it so that its useful significance disappeared under the new title and point of view—created a new thought for that object. He concluded his text by saying, "As for plumbing. . . . The only works of art America has given are her plumbing and her bridges." Like the skyscrapers, these are good, practical things. These are not, as Arensberg said, an aesthetic contribution. Turning it on its back ensured that "its useful significance disappeared."

Andy Warhol's contribution to the definition of art was made not through a text, but through a remarkable body of sculptures, which constituted his first project upon taking possession of the

Silver Factory in 1963, and was shown the following spring at the Stable Gallery, which is today the business entrance on 74th Street of the Whitney Museum of Art. The *Brillo Box* became a kind of philosophical Rosetta Stone, since it allowed us to deal with two languages—the language of art and the language of reality. The partial definition of art that I developed in *The Transfiguration of the Commonplace* was the result of reflections on the questions this remarkable object raised.

The leading aestheticians in America before what we may as well call the Age of Warhol were greatly influenced by a famous analysis in Ludwig Wittgenstein's *Philosophical Investigations*, in which he generated what seemed like a powerful attack against the search for philosophical definitions, which in a way was Socrates' contribution to philosophy, at least as he is portrayed in the dialogues of Plato. The dialogues usually show Socrates in discussion with a circle of various Athenians. They address concepts like justice, knowledge, courage, and others, including art—though the Greeks had no word for art—which everyone in the culture more or less knows how to use. There would have been definitions in the dictionary, if ancient Greece had dictionaries, but no one would look them up, since the terms Socrates is interested in are used by everybody in daily conversation. Thus in the dialogue *The Republic*, which deals with a kind of ideal society, the topic is justice. Socrates asks an elderly businessman named Cephalus what he considers justice to be. Cephalus answers that it is paying one's debts and keeping one's promises—certainly the code of an upright man of business. Socrates then offers a

counterexample. Would it be just to return a weapon to a man who has since gone mad? True, it belonged to him and he has a right to have it. But weapons are dangerous, and one can no longer be confident that the owner of the weapon knows when to use it. The form of the dialogue consists of a thesis, an antithesis, and a revision of the thesis in the light of the antithesis, until the participants cannot go any further. In the *Theaetetus,* Socrates and a gifted young mathematician define knowledge as true belief, though they realize that there is more to knowledge than that. Epistemologists have added further conditions in recent times, but no one thinks we are home-free. Socrates defines art as imitation in the tenth book of *The Republic,* which certainly captures Greek sculpture. Naturally Socrates looks for a counterexample and quickly finds one—namely, a mirror—which gives us reflections effortlessly, and better than anyone can draw.

Everyone generally knows what justice is, or knowledge. The definition of knowledge in *Theaetetus* consists of two conditions, but the search for further conditions is a vital part of epistemology. Socrates' definition of art crumples totally when abstraction and then readymades come along in the twentieth century. Beyond question, most works of art in the West have been mimetic, to use the word derived from the Greek, and Western artists have become more and more adept at it. When the camera was invented, it took some decades before the human face could be rendered lifelike, but the camera did not invalidate as art early efforts at imitation, like those of Giotto or Cimabue. But imitation can no longer be part of the definition of art, since Modern

and contemporary art is full of counterexamples. But one cannot be expected to know what art will be like in two millennia! Only if art has reached an end can that be. Socrates, for all his sharpness, has little to say about the future of art. He seems to imagine that things basically will go on as they are, so far as art is concerned. Abstraction and readymades make it increasingly difficult to find a definition of art. That is why the question "What is art?" has been raised more frequently and often more heatedly. The nice thing about imitation is that people in general are able to identify art in cultures such as the one in which Socrates offered his definition of art. But how useful are definitions? Wittgenstein offers an example in which definitions seem useless, since we can do without them: the concept of *games*.

We can usually pick out which activities are games. But when we consider the array of games—hopscotch, poker, ring around the rosie, pick-up sticks, spin the bottle, hide-and-seek, Simon says, and countless others—it is difficult to identify what they have in common. It is accordingly difficult to see how we could possibly frame a definition, though children rarely have difficulty in picking up and playing different games. Someone might say games are play, and not serious. But that can't be part of the definition, since people riot when their teams lose. It would not stop them from doing so if we tried to say "It's only a game." So we don't have a definition and, Wittgenstein claims, having a definition would not make us wiser. The best we can do is find a *family resemblance*. Thus a child might have its father's nose and its mother's eyes. Or we can imagine a set of things: *a, b, c, d.*

But though *a* resembles *b*, *b* resembles *c*, and *c* resembles *d*, *a* does not resemble *d*. So there is no ovearching property on which to base a definition. How interesting, followers of Wittgenstein thought, that games should not share a common property! Even philosophers did not look further.

In 1956 an effort was made to replace the paradigm of games with the paradigm of artworks. An important paper, "The Role of Theory in Aesthetics," was published by Morris Weitz, who argued that "art" is an *open concept*, which seems intuitively true if we consider the immense variety of objects in an encyclopedic museum. Weitz himself used the far less compelling example of novels, but though there are great differences between Jane Austen's novels and those of James Joyce, the history of visual art would appear more open by far if we track the changes beginning with Manet to, well, Picasso's *Les Demoiselles d'Avignon*. With the visual arts, moreover, more and more traditions of art from the different cultures were franchised for what I have called the Art World, which consists of all the artworks in the world. What does it take for an object to be an artwork in the light of changes in museum acquisitions? How does something get enfranchised as part of the Art World? Blacks and women in America were long prohibited from voting, hence they were disenfranchised. Unquestionably this was grounded in a wide belief in their inferiority. But in fact it rested on racism and sexism. Ultimately, blacks, abetted by whites, were able to help other blacks to claim their civil rights. The brutality that was televised worldwide ultimately led to the end of most Southern resistance. In 2008 the contest

for the Democratic nomination for president was between a black man and a woman. Race and sex had become legally irrelevant.

In the sixties the philosopher George Dickie developed a theory known as the Institutional Theory of art. It more or less overpowered Weitz's theory of art. In response to criticisms, Dickie has developed various versions of institutionalism, but it basically states that determining what is art is altogether a matter to be decided by his designation of the Art World, which he defines differently than I do. For Dickie, the Art World is a sort of social network, consisting of curators, collectors, art critics, artists (of course), and others whose life is connected to art in some way. Something is a work of art, then, if the Art World decrees that it is. Duchamp's idea that Mr. Mutt chose to turn a urinal on its back transformed it from a piece of plumbing to a piece of art. But there has to be some reason for the members of the Art World to judge something to be art. Arensberg felt that Duchamp wished to make the urinal's beauty salient. Someone else might have said that he wanted to draw attention to the eroticism in putting it on its back with the drain holes as the female urinary outlet. Dickie's idea turns out to be like knighthood; not everyone can do it, it has to be done by kings or queens. The knighted individual kneels, and then rises once his or her knighthood has been conferred. But even there, some knightly reasons can be stated: dragons were slayed, maidens were rescued, and the like. Some mad king might confer knighthood on his horse. He would have that power, though he might justify the knighthood in the light of the horse having brought his master out of danger. In Plato's dialogue

Euthyphro, Socrates mounts a strong argument against a sort of priest who, by appealing to the knowledge that the gods love people, claims to know what things are just. Socrates responds by asking whether the gods love them because they are just, or are they just because the gods love them? If it is because the people are just, we can know as well as the gods what is just. But if the people are just because the gods love them, why should we accept that the people are in fact just? Customs officials consulted the head of the National Museums of Canada on whether ready-mades were sculpture, since he was believed to be an expert. He said flatly that they were not. Just being a member of the Art World does not validate his judgment. So at the very least there are difficulties that have to be resolved if the Institutional Theory of art is to be accepted.

To return, then, to Weitz's theory, 1956 was not a good year for theorizing about art. It was the high watermark of Abstract Expressionism. But everything changed in the next decade, when, in Pop Art, Minimalism, and Conceptual Art, works of art appeared which were unlike anything seen before. The painter Barnett Newman defined sculpture as something you bump into when you back up to get a better look at a painting. But in the early seventies, sculpture experienced a breakthrough, beginning with Eva Hesse. Then came Robert Smithson, Gordon Matta-Clark, Richard Serra, Sol LeWitt, and Charles Simonds. Matta-Clark cut up houses, Smithson did *Spiral Jetty*, Serra used the wall and floor of Leo Castelli's warehouse as a mold for casting ingots, LeWitt used cinder blocks to make monuments, and Simonds made little

clay dwellings in the cracks of buildings in what was going to be SoHo—which he insisted were occupied by "Little People."

Weitz and his supporters might say that the sixties and seventies merely further validate his idea that art is an open concept, which was sometimes referred to as "anti-essentialism." I on the other hand am an essentialist. My thought is that the logic of art history really makes it appear that art is an open concept: even if Greek art was mimetic, Romanesque art was hardly so. Abstraction proves that imitation does not belong to the essence of art—and neither does abstraction. We don't really know what belongs and what does not. My view, though, is that Warhol helps us see what is likely to belong to the essence of art for as long as art is made. The problem is that philosophers, of all people, conclude that art is an open concept because they cannot find a set of common visual properties. I think they stopped looking, since I know of at least two properties inherent in artworks, and these then belong to the definition of art. All we need to do is hunt around a bit and find a property that works of art have in common. In the time of Wittgenstein, philosophers put great confidence in being able to pick out which creations are the artworks. Picking them out is really not to get very much out of them. You have to address them as works of art. You have to treat them as *art critics* would. You want to have an open mind, rather than an open concept.

The Stable Gallery was located on the ground floor of an elegant whitestone townhouse, with black and white marble tiles in the entryway, and a curving staircase with a polished brass bal-

ustrade. The gallery itself was to the left, behind a baronial door of varnished mahogany. It was a far cry from the actual stable in which the gallery was previously situated and that gave it its name. It was really one of the beautiful galleries in New York. Upon entering, one felt one had made a mistake. It looked like a supermarket stockroom. All the furniture had been removed, and there were just rows of cartons, with the boxes neatly stacked— Brillo, Kellogg's, Del Monte, Heinz, etc. Delighted visitors who had purchased cartons at the gallery attracted attention outside on the street as they walked along carrying the plastic-wrapped works.

The individual boxes looked as much like actual commercial containers as Andy and his helpers could make them. They were fabricated in a woodworking shop to Andy's specifications. Real cartons were photographed and the labels then stenciled onto the fabricated boxes, making them, as Gerard Malanga, Warhol's assistant, said, three-dimensional photographs. Except for the occasional drips, his boxes look just like the real boxes, designed, in the case of Brillo, by James Harvey, actually a second-generation Abstract Expressionist. The point of the work was to subtract the perceptual differences between art and reality. A marvelous photograph by Fred McDarrah shows Andy standing among his boxes, like a stock boy in the stockroom, his pasty face looking out at us. Nobody would pay attention to the drips, if they could be seen at all.

The question, then, was, in what way did Andy's Factory-made boxes differ from the factory-made boxes? That is, what differenti-

ating visible properties separated them? The Factory-made boxes were wood, while the factory-made boxes were fashioned from corrugated cardboard. But the difference between them could have been reversed. The Factory-made boxes were painted white, with the design stenciled onto four sides and the top, but so were many of the factory-made boxes. Other factory-made boxes were unpainted except for the logo—they were the normal brown of unpainted corrugated cardboard. The commercial boxes contained scouring pads, while Andy's boxes had no such contents, but he could have filled his boxes with the pads and they would still be art. Could members of the Art World differentiate them as art? Maybe—but they would be guessing. Externally, both sets were alike.

My sense is that, if there were no visible differences, there had to have been *invisible* differences—not invisible like the Brillo pads packed in the Brillo boxes, but properties that were *always* invisible. I've proposed two such properties that are invisible in their nature. In my first book on the philosophy of art I thought that works of art are *about* something, and I decided that works of art accordingly have meaning. We infer meanings, or grasp meanings, but meanings are not at all material. I then thought that, unlike sentences with subjects and predicates, the meanings are *embodied* in the object that had them. I then declared that works of art are *embodied meanings*. Most philosophers of language are fixed on semantics, analyzing sentences in such a way that the subject falls within the scope of the predicate. Except for Wittgenstein, who offered in his great early work, *Tractatus*

Logico-Philosophicus, the thesis that sentences are pictures and the world itself is made up of facts that pictorial sentences match, leaving the question of what happens when they don't. The opening sentence of the *Tractatus* is: "The world is the sum total of facts, not things." Semantics uses external relations like "denotation" or "extension." But the kind of relationship art depends upon is internal. The art object *embodies* the meaning, or partially embodies it. Suppose an artist sets out to paint some murals that celebrate important laws of science. He paints a single horizontal unwavering line on one wall and, on the facing wall, he paints a dot. The two walls together picture Newton's first law of motion: "Every object at rest stays at rest, and every object in motion stays in motion unless it is acted upon."

I must admit that I have done relatively little to analyze embodiment, but my intuition was this: The artwork is a material object, some of whose properties belong to the meaning, and some of which do not. What the viewer must do is interpret the meaning-bearing properties in such a way as to grasp the intended meaning they embody. An example I often use is Jacques-Louis David's 1793 *Marat Assassiné*—Marat Assassinated—which represents a scene from the then ongoing French Revolution. Marat was an incendiary blogger, to use the current term, who wrote for the publication *Friend of the People*. He was stabbed to death by an aristocrat, Charlotte Corday, who had come to petition this powerful figure on behalf of her brother. Marat is said to have begun to write a pass for Corday's brother when she stabbed him to death. Since Marat represented the revolutionaries, there was a

general sense that the event should be painted by David, himself on the revolutionary side, so when the people shouted, "David, take up thy brush," he had little choice. But he painted not a crime scene, but rather a metaphoric scene of the meaning of the work.

Here is an interpretation of his painting. David portrays Marat in the bathtub, where he spent considerable time because the bathwater helped ease the pain he suffered from a noxious skin disorder. In front of him is Corday's dagger and some spilled blood. Marat is lying back, in death, with the instrument of his death in front of him. I interpret Marat in his bathtub as comparable to Jesus in his sepulcher. The painting suggests that he will rise up as Jesus did, but in any case, there is also the thought that he died for the viewer as Jesus died for Christians, so Marat is a corresponding martyr for the sansculottes, as the ordinary revolutionaries were called. But just as Jesus expected something of those present, namely that they should follow in his steps, there is an injunction that, since Marat died violently for the Revolution, you, the viewer, must follow in Marat's steps. The viewers are part of the picture, even if not seen. David was addressing them as they stood before the very compelling representation of a very central moment. The scene appeals to the revolutionary audience. One may say that the fact that it is painted on canvas does not enter into the meaning. It just supports the painting. It is not at all part of the meaning, even if it is part of the object that embodies the meaning. The explanation that an embodied meaning is what makes an object a work of art applies as much

to David's work as to Warhol's. In fact it applies to everything that is art. When philosophers supposed that there is no property that artworks share, they were looking only at visible properties. It is the invisible properties that make something art.

Of course, a property could be both, part of the object and of the meaning. A convenient example might be a Donald Judd sculpture, which typically consists of a row of uniform compartments, often facing the viewer, and is made of sheet metal and is coated in enamel. Typically they were titled "Untitled," mainly, I would suppose, to inhibit the viewer from giving them a specific meaning, like "desktop." Judd wanted them to be seen as "specific objects" and not as imitations of specific objects. He wanted them, that is, to enrich the inventory of the world. Judd sent his pieces to a machine shop to be fabricated, since it lay beyond his powers to make sufficiently sharp corners. The corners were naturally properties of the object, but they entered into the meaning of the work, contributing to its specificity.

I quite realize that there may be more conditions for a definition of art. It took millennia to add conditions to the two that Socrates and Theaetetus found in the definition of knowledge. But I can imagine the aestheticians of various cultures saying that my definition does not explain why people are moved or revolted by this or that work. Of course, the aestheticians don't explain things like that. They help identify the artworks of a given culture, but these, which vary from culture to culture, do not belong to the definition of art. The definition has to capture the universal artness of artworks, irrespective of when they were made or will

be made. We have to learn, from culture to culture, how to inter-
pret them and fit them into the life of that culture, like icons, for
example, or fetishes. And, of course, they have the style that is
appropriate to the culture in question. They have to have the *style*
that belongs to that culture.

From that perspective, it is worth considering the Brillo box's
style, designed by James Harvey, whose day job was as a commer-
cial designer.

To begin with, his Brillo carton is not simply a container for
Brillo pads; it is a visual celebration of Brillo. You can verify this
by looking at the way Brillo is shipped today, in a plain brown
wrapping like pornographic literature. The difference between
the container of 1964 and the container of today expresses as elo-
quently as anything could the difference between then and now.
The 1964 box is decorated with two wavy zones of red separated
by one of white, which flows between them and around the box
like a river. The word "Brillo" is printed in proclamatory letters:
the consonants in blue, the vowels—*i* and *o*—in red, on the river
of white. Red, white, and blue are the colors of patriotism, as the
wave is a property of water and of flags. This connects cleanliness
and duty, and transforms the side of the box into a flag of patriotic
sanitation. The white river metaphorically implies grease washed
away, leaving only purity in its wake. The word "Brillo" conveys
an excitement which is carried out in various other words—the
idioms of advertising—that are distributed on the surfaces of the
box, the way the idioms of revolution or protest are boldly bla-
zoned on banners and placards carried by demonstrators. The

pads are GIANT. The product is NEW. It SHINES ALUMINUM FAST. The carton conveys ecstasy, and is in its own way a masterpiece of visual rhetoric, intended to move minds to the act of purchase and then of application. And that wonderful river of purity has an art historical origin in the hard-edged abstraction of Ellsworth Kelly and Leon Polk Smith. As I suggested above, the design exalts its own contemporaneity and that of its users, who belong to the present the way members of what was called the "Pepsi generation" were congratulated for their nowness.

Nevertheless, the factors that engender the Brillo boxes' goodness contribute nothing whatever to what makes Warhol's *Brillo Box* good or even great art. All the grocery boxes have the same philosophical properties. It is important to remember that all the philosophical points *Brillo Box* helps us see could have been made by means of any of the more humdrum cartons also fabricated for the Stable Gallery show. We cannot allow what makes Harvey's box so successful to penetrate the art criticism of Warhol's box! The art criticism for *Brillo Box* really cannot differ significantly from the art criticism of any of the cartons Warhol made or could have made instead of it. Philosophically speaking, the design differences between the different sets of cartons are irrelevant. Warhol was not influenced by hard-edged abstraction: he reproduced the forms of an existing artist (Harvey), only because the forms were already there, the way the logo of the Union of Orthodox Rabbis was there, certifying that Brillo was kosher (as it was in 1964). It was essential that Warhol reproduce the effects of whatever caused Harvey to do what he had done, without the

same causes explaining why they were there, in his *Brillo Box* of 1964.

So how does art criticism come in? It comes in because commercial art through its ordinariness was in some way what Warhol's art was about. He had a view of the ordinary world as aesthetically beautiful, and admired greatly the things Harvey and his Abstract Expressionist heroes would have ignored or condemned. Andy loved the surfaces of daily life, the nutritiousness and predictability of canned goods, the poetics of the commonplace. Roy Lichtenstein once said in my presence, "Isn't this a wonderful world?," adding that it was something Andy said all the time. But in terms of ordinariness there is nothing to choose between in considering the various cartons he had fabricated for his exhibition. This approach shows a philosophical shift from the rejection of industrial society—which would have been the attitude of William Morris and the Pre-Raphaelites—to endorsement, which is what one might expect from someone born into poverty and who might therefore be in love with the warmth of a kitchen in which all the new products were used. So the cartons are as philosophical as the wallpaper of William Morris, meant of course to transform rather than celebrate daily life and, in Morris's case, to redeem its ugliness into a kind of medievalized beauty. Warhol's boxes were a reaction to Abstract Expressionism, but mainly with respect to honoring what Abstract Expressionism despised. That is part of the art criticism of *Brillo Box,* and there is a great deal more. But the two pieces of art criticism are disjoint: there is no overlap between the explanation of Harvey and the explanation of

Warhol. Warhol's rhetoric has no immediate relationship at all to that of the Brillo boxes as such.

There is one problem in concluding that the commercial Brillo box is what Warhol's *Brillo Box* is about. Although I would have hoped for the contrast to be between art and reality, it is hard to deny that Harvey's Brillo box is art. It is art, but it is commercial art. Once the design is set, the cartons are manufactured by the thousands. They are made of corrugated cardboard to protect the contents while still being light enough to be lifted and moved, and to allow for easy opening. None of that is true of Andy's boxes; only a few were made, and their purpose was purely to be seen and understood as art. It is pure snobbishness to deny that commercial art is art just because it is utilitarian. And besides, cardboard boxes are part of the Lebenswelt. Andy's box is not. It is part of the Art World. Harvey's box belongs to visual culture, as that is understood, but Andy's boxes belong to high culture.

Lichtenstein, who had a revolutionary agenda, wanted to bring vernacular art into the art gallery, which until then had been open only to fine art. So he painted panels from comic strips, as in his wonderful painting *The Kiss,* which shows a pilot and a girl kissing. The pilot is in uniform, the girl is wearing a red dress and red lipstick. But that is not vernacular, like a page from a comic strip would be—say, *Terry and the Pirates,* which would be published by the thousands. Roy's painting is unique. We can display sheets of comic strips in a gallery open to vernacular art, but since the sixties we have opened it to *paintings* of vernacular art, especially in showing Pop Art. We wrap food in the funny papers, or dump

44

coffee grounds in them—but it would be barbarism to do such things with *The Kiss* by Roy Lichtenstein.

I am not really an art historian, so I had no interest in Warhol's influences when he had the idea of making those cartons—if, indeed, he had any influences then. I am reasonably certain that Warhol had not read much philosophy. But I felt I saw certain philosophical structures in the pairing of an artwork with an object it resembled, even if the object and the artwork were perceptually indiscernible. In fact, philosophy is full of such examples, such as the contrast between dream and perception when the content is the same—for instance, René Descartes's *Meditations,* a book that undertakes to find what, if anything, its author knows with certainty. The mise-en-scène provided by his *Discourse on Method* has Descartes returning from the wars in Germany, when he becomes snowbound. Since he has nothing more pressing to do, he applies himself "earnestly and freely to the general overthrow of all my former opinions."

He peels off the layers of belief like an onion. "All that I have, up to this moment, accepted as possessed of the highest truth and certainty, I received either from or through the senses. I observed, however, that these sometimes misled us, and it is the part of prudence not to place absolute confidence in that by which we have even once been deceived." This may be too harsh a move. There may have been cases under less than ideal circumstance in which anyone may make a mistake. Still, there are things I cannot honestly doubt: "How could I deny these hands and this body, and

not be classed with persons in a state of insanity, whose brains are so disordered and clouded by dark bilious vapors as to cause them pertinaciously to assert that they are monarchs when they are in the greatest poverty . . . or that their head is made of clay, their bodies of glass, or that they are gourds." But then it occurs to him that, though he feels certain that he is holding a piece of paper that he looks at, "How often I have dreamt that I was in these familiar circumstances, that I was dressed and occupied this place by the fire, when I was lying undressed in bed? I perceive clearly that there exist no certain marks by which the state of waking can ever be distinguished from a vivid dream of ordinary life. I almost persuade myself that I am now dreaming."

There is no internal way of distinguishing between dreaming and perceiving. Not always, but sometimes. Sometimes I dream I am writing a book on a computer when in truth I am in bed asleep. There are cases in which dream and waking experiences are indiscernible, which is our circumstance with the *Brillo Box* and the Brillo box. They are for all practical—and philosophical!—purposes entirely alike. And that makes the first part of the first "Meditation" much like the case of the artwork *Brillo Box* and the ordinary commercial Brillo box. We cannot distinguish the artwork from the ordinary Brillo box, at least as far as each of them meets the eye.

Consider those wonderful drawings by Saul Steinberg, in which a commonplace box dreams of the perfect portrait, in which all edges and corners are perfect. Warhol at first thought he would save money and labor by using ordinary cardboard boxes from the

wholesaler. But the edges and corners were too soft and rounded. They were inconsistent with his vision. So he had to take the route of fabrication and stenciling. The stencil gave perfect similarity, but you could not stencil the physical properties of the box. Cardboard is perfect for shipping but not for geometry, whose properties Warhol wanted for his boxes. Sharp corners and edges, as Judd was aware, belong to a dream of exactitude.

In the first known effort at defining art, Socrates, we recall, explained it as mimesis. But though he was a sculptor, so far as he had a job, he designed as ideal a republic that saw no need for artists, who might as well be exiled. At one point Socrates outlines the various divisions of the universe: an upper and lower level, the former being invisible, the latter visible. The upper level of visibility consists of things that carpenters make—tables and chairs. These conform to the concepts, which are invisible but accessible to intellect. At the very bottom of the visible world are shadows and reflections, like mirror images. Photographs did not exist in Plato's time, but they may be classed as reflections of things, and so may paintings, or art in general. In some versions, dreams belong to this lowest level. It represents things. They are made of visible qualities, but they may not be real. I mean that I might dream of my dead wife, which shows her as much as an oil painting would.

I like the way in which art is like a dream in two great philosophical visions. We could add "dreamlike" to meaning and embodiment. Novels are like dreams, as are plays. It is not necessary that they be true, but it is possible. There is something very

compelling in the relationship between art and dream. By contrast with carpenters and craftsmen, those who paint only need know how things appear. They need not be able to make a chest, but they can paint a picture of a chest without that knowledge. Socrates had a soft spot for craftspersons. In Book Ten of *The Republic*, which begins with Socrates' putdown of mimetic art, he tells a story with which he ends the great dialogue. It is the story of Er, a heroic soldier who seems to have been killed in action, but his body did not decay—there was no stench—and he was accordingly not cremated in a funeral pyre. Instead, Er went underground, joining the spirits of the dead. They are instructed in how to choose their next life. At "graduation," they are taken to a meadow where lives are all laid out for them to choose from, as if they were garments. In a way, each chooses a life that seems more desirable than the life left behind. I cannot address them all, but one man, Epeus—an artist, in fact—who designed the Trojan horse that helped the Greeks penetrate Troy by hiding in the horse's body, took the soul of a woman "skilled in all the arts"—a craftswoman. In another dialogue, *The Statesman*, Socrates decides that the ruler should be a weaver, since the art of the statesman is to weave together the different strands that make up the state. The crafts are higher because they are more useful than the arts, which deal only in appearances.

I have decided to enrich my earlier definition of art—embodied meaning—with another condition that captures the skill of the artist. Thanks to Descartes and Plato, I will define art as "wakeful dreams." One wants to explain the universality of art.

My sense is that everyone, everywhere, dreams. Usually this requires that we sleep. But wakeful dreams require of us that we be awake. Dreams are made up of appearances, but they have to be appearances of things in their world. True, the different arts in the encyclopedic museum are made by different cultures.

I have only just begun to think about wakeful dreams, which have the advantage over the dreams that come to us in sleep in that they can be shared. They are accordingly not private, which helps explains why everyone in the audience laughs at the same time, or screams at the same moment.

There is another advantage, in that they raise important questions for the End of Art, which I conceived of in 1984. One argument for the End of Art is that it rests on the fact that art and reality are in certain cases indiscernible. I thought if art and reality were indiscernible, we had somehow come to the end. Art and reality could in principle be visibly the same. But I had not realized at the time that the differences are invisible, as we saw in distinguishing the Brillo box from the *Brillo Box* in that they have different meanings and different embodiments. The Brillo box of the supermarket glorifies the product Brillo by all the slogans on the box, as we noticed in analyzing the supermarket boxes. Warhol's *Box* denotes the Brillo boxes. It embodies the latter in that the two look the same. Art always stands at a distance from reality. Thus two Brillo boxes don't denote one another.

A 2005 work by the Appropriationist Mike Bidlo looks as much like Warhol's *Box* as the latter looks like supermarket Brillo boxes. Bidlo's denote all the 1964 *Brillo Boxes,* and this is worth noting.

He did what he did because he wanted to understand what went into making them just as he replicated some Jackson Pollocks in order to learn what was involved in a real Jackson Pollock. In a way, Warhol's *Box* was the defining work of the sixties, while Bidlo's was the defining work of the eighties.

In 1990 the celebrated curator Pontus Hultén, who gave Andy a show at Moderna Museet in Stockholm in 1968, had carpenters fabricate around a hundred Brillo boxes in Lund after Andy's death, which he then authenticated. His boxes were counterfeit, as were the certificates. At the time, 1964 *Brillo Boxes* rarely came up for auction, but when they did, the starting bid was $2 million. Hultén died before he was exposed. The authenticated boxes were not authentic. They were forgeries. As far as I know, they were worthless. Still, there may be a run on them, people having all the fun of an Andy but also all the fun of calling them fakes that could not easily be told apart from the real thing. We now have four distinct boxes. But there are certainly going to be more, all meaning something different. That feels like End of Art!

Every work of art, if my thesis is true, embodies meanings. But that does not mean they ever have to look like one another! During a lecture I gave at the Sorbonne I invited the audience members to come to a show of my wife, Barbara Westman, whose drawings were on display at the Galerie Mantoux-Gignac, in the rue des Archives in Paris. One of them wrote me a note, saying that he was happy that it did not consist of *Brillo Boxes!* In truth, the immense variation in how artworks look is probably what

made philosophers consider that art is an open concept. One contribution of Cage was the discovery that any noise can be a musical noise if it happens whenever "4′33″" is played. In the Judson Dance Theater, it was possible to perform dance movements that are indiscernible from ordinary actions, like eating a sandwich or ironing a skirt. What happens in such cases is that ironing a skirt is what the dancer's movements mean, and hence "ironing a skirt" is embodied in her body. That does not happen when someone just irons a skirt—the action of ironing a skirt is performed because the ironer intends that it be free of wrinkles. That is not what the Judson dancer did. She performed a dance step that exactly resembles a practical chore. It is a clear case of imitative art! But the act that it resembles isn't imitative at all, though there may have been some imitation involved in learning to iron. I remember seeing Baryshnikov imitate a football player, holding his arm out to fend off would-be tacklers. I had never seen something like that. He really did imitate a football player, though the imitated football player was simply keeping others at a distance.

What makes modern imitation dreamlike is that it is not true that it is a move in, for example, a football game, even if a football player made the same moves. But it is a wakeful dream in that the dancer intends that those in the audience see what is being imitated, and that a large portion of the audience read that movement as a football move, even if the football is missing. The perception is shared in a way dreams never are shared, even if a dreamer dreams about running with a football.

Any movement can be a dance movement and hence achieve

the dreamlike. The same may be true of acting, as when, for example, an actress serves cocktails that are actually glasses filled with just water. To taste the tasteless is a kind of bad dream. It is not possible to catalog all the different ways artists have found to dream-ify. I'll take a flier at Michelangelo's masterpiece, the great decoration of the Sistine Chapel's vault, with the scenes of a narrative in which, when I first saw it, figures move in and out of an enveloping dark.

RESTORATION AND MEANING

> The Sistine Chapel looks like an enormous drawing by Daumier.
> —Pablo Picasso

> A marvelous draughtsman but a poor painter.
> —Jean Cocteau

These judgments—that the Sistine ceiling was basically a drawing and that it was essentially monochrome, like the sepia panels painted by Daumier—are reports from the past that tell us how the ceiling looked in the 1930s, when the two men spent time in Rome with the Ballet Russe de Monte Carlo. They tell us what the ceiling looked like before the most recent cleaning, which was approved in 1994. I visited Rome in 1996 as a guest of the American master Cy Twombly, who was enthusiastic about the restoration, which, he argued, proved that Michelangelo was truly a great painter. Before I left New York I had been persuaded by my colleague James Beck that the restoration was a catastrophic failure. I had seen it when it looked much as Picasso and Cocteau described, except that I felt it was sublime. Until I

discussed it with Twombly and his associate, Nicola Del Roscio, I had resolved to give it a pass.

The former director general of the Vatican Museums, Carlo Pietrangeli, writes in the preface to a publication about the restoration: "It is like opening a window in a dark room and seeing it flooded with light." But what if it changed the meaning of what was seen before the presumably dirty window was opened? Then there is a possibility that we had for centuries been deceived regarding what Michelangelo's intentions actually were. Some of the arguments connected with the restoration were scientific, some were art historical. But I nowhere saw a philosophical argument. Since my definition is intended as a piece of philosophy, I want to address the restoration from the perspective of what art is, understood philosophically.

A few years after the heavily controverted cleansing of the Sistine ceiling was completed, a book so opulently expensive that review copies were merely lent to reviewers, and delivered by what the publishers boasted were "bonded messengers," undertook definitively to answer the criticisms by reproducing the beauty Michelangelo's contemporaries allegedly beheld. The publicity flyer for the book shows the famous face of Michelangelo's Eve both pre- and postcleaning, comically like those before-and-after juxtapositions which prey on our secret hopes and agonies— frog to left, prince to the right; ninety-pound weakling to the left, Mr. Universe to the right, confident in his superb muscularity; mortifyingly beaky nose to the left, perky turned up Miss American Pie nose to the right, as in Andy Warhol's great *Before and*

After of 1961. Eve Before differs from Eve After primarily because a coating of animal glue, injudiciously applied around 1710—roughly two centuries after the great vault was completed—left a triangular patch down Eve Before's cheek.

The differences, including the patch, seem hardly dramatic enough to justify the before-after format: it is not as though Eve After shows us anything not already visible in Eve Before, and the patch itself would be largely invisible to those standing sixty-eight feet below, on the chapel's floor. A cannon shell went through the ceiling at the time of the War for Unification, removing a fairly large segment from the *Deluge,* but this is hardly noticed by those caught up in the great epic above their heads. If what was removed from Sistine ceiling Before to yield Sistine ceiling After is illustrated by the two faces of Eve, there could scarcely have been grounds for controversy. No one's perceptions of that face could have been greatly changed by the cleaning. Nothing of substance to the interpretation of the work could have been greatly changed, if this is the evidence. The faces do differ in tonality and warmth—but aesthetics can hardly discriminate them as better and worse. The earlier would best correspond to what we suppose were Michelangelo's intentions—but is Eve After so divergent from those intentions to justify the immense risks to which restoration exposed this irreplaceable work? There was no simple answer. What one group perceived as soil of time on the ceiling before it was cleaned, another saw as a kind of metaphysical twilight central to Michelangelo's expression: figures seemed to struggle out of and sink into the darkness the way the bound slaves struggle out

of and sink into the stone in certain of the sculptures meant for the Julian Tomb, and the ceiling as a whole had in consequence a heroic dimension now quite washed away, a loss for which the recovery of the original colors is not even imaginably worth the risk, especially if, with Plato, we think of ourselves as imprisoned in a cave, from which a fortunate few escape into the light. But if what seemed like metaphysical transfiguration was merely an artifact of candle soot and incense smoke, the work may have lost the sublimity long incorrectly ascribed to it.

So the expensive picture book's before-and-after shot of the ceiling in mid-cleaning is inconclusive. It looks like a contrast between rotogravure and the color pages, but that may be a category mistake of the first order. Certainly much of what the book showed were stiff and awkward figures in almost lurid Mannerist colors, stripped, mostly, of any sense of cosmic struggle. It feels much as if, if this is what Michelangelo painted, he was far less great an artist than we had believed; rather he was indebted, as it were, to time and grime as benign collaborators. But suppose what had been washed away was the metaphoric shadow of the human condition as emblematized by Plato's cave, so that the intensification of color was purchased at a terrible expenditure of now lost meaning? Often the figures look crude at close range— so crude that it is easy to agree, on the basis of the book, with those who claim the work was ruined. I have to concede that I was enough convinced by critics of the restoration, one of whom described the restoration as an artistic Chernobyl, to refuse to visit the chapel on principle, preferring my memory to a panorama of

terrible loss. And I was deeply suspicious of the evidence that the ceiling was in serious danger of falling, based upon a small piece of painted plaster found on the chapel floor. How difficult would it have been to have planted that, preying on the fears—and cupidity—of those anxious to clean this masterpiece at any cost?

So we are left with a choice of whether what has been taken away is dirt or meaning. It is here, I suppose, that the bound slaves become so important, since they provide an analogy to the figures in the ceiling—these struggling to free themselves from matter, those from darkness, if the engulfing darkness corresponded to the uncarved stone of the sculptures—integral, in either case, to the meaning of the works. There are two ways of thinking of restoration with the sculptures, one far more radical than the other. Their patination could be scrubbed away, leaving them bright and somewhat raw, and just as Michelangelo's contemporaries saw them. With this there would be no loss of meaning, and it would be a mere matter of taste which was the preferred state. Suppose instead that someone decided to carve away the uncarved stone, releasing the figure as Michelangelo intended. He famously declared that his aim as a sculptor was to release the figure from the stone, and our imagined "restorer" might say he was merely helping to realize Michelangelo's intention. We would certainly not see them as Michelangelo's contemporaries did. But far more important is the fact that in losing the uncarved block, we might have lost a priceless meaning. The problem with the ceiling is that the darkness can be read as patination, loosely speaking, or as metaphysically analogous to the unremoved stone and hence

part of the meaning. I once heard a guard at the Uffizi answer a tourist's question about the "Unfinished Michelangelo" with "Si Michelangelo è finito, è finito!" The duality of unfinished as against finished is underdetermined by what we see. But so is the duality between dirt and metaphysics underdetermined by what we saw but no longer see. So the question returns: Was the darkness a physical consequence of age and abuse, rightly removed by an advanced science of restoration, or was it part of the artistic intention of the work, to our irremediable loss arrogantly cleansed away?

It may be conceded that one could not wash away something that belonged to true fresco, just because of the chemical interaction between lime and water that creates the crust of calcium carbonate and gives fresco its permanence. It is like washing porcelain. But paint can be applied *a secco,* over the carbonized pigment. What if Michelangelo added that which gives the metaphysical interpretations their purchase a secco, after the individual frescoes were indelibly fixed? This is not as readily settled by appeal to objective observation as the condition of the stone is in the bound slaves. Indeed, it might be enough an open question that the more conservative course would have been the wiser, leaving it possible that in removing the dirt we were washing away what had been put there by Michelangelo, intending that play of light and dark which serves as metaphor for the strivings of the incarcerated soul. There would then be a question of whether, in removing the grime, we were not removing something more.

How can such a question be closed? In my view, one would

have to determine whether such a metaphysical intention is really consistent with, let alone entailed by, the meaning of the actual episodes Michelangelo depicted across the vault. In this I differ from Gianluigi Colalucci, who was responsible for the restoration, and who sought to sidestep interpretation by restricting his focus to the condition of the paint, treating the ceiling as a physical object. "Today in art conservation, objectivity is at the root of a proper working method," Colalucci insists. Notwithstanding the fact that "the debate over the cleaning of the Sistine ceiling assumed violent and even apocalyptic overtones," it would only be by proceeding objectively—"Step by step and brushstroke by brushstroke"—that we could arrive at knowledge of "the true nature of Michelangelo's art." And Colalucci voices his restorer's credo: "I believe that the best approach to working on Michelangelo is absolute passivity. . . . If we attempt to interpret a work of art, we end up imposing conditions on the cleaning process." My view, by contrast, is that interpretation should impose conditions on the cleaning process, and that what Colalucci achieved might have been defended by arguing that nothing internal to the meaning of Michelangelo's imagery entails an interpretation of the ceiling based on the almost monochrome play of light and dark the Neoplatonic reading of it requires. There is reason to be disturbed by the restorer's agenda of willed passivity, which seeks to answer questions about the work "objectively," with reference to the paint alone, especially since secco additions to the painting's surface could have been placed there by Michelangelo's hand. But Colalucci declares that "nine and a half years of daily contact with

Michelangelo's frescoes brought me close, if such a thing is possible, to the artist and the man." And he offers in evidence the way in which (before) "the banal, pale burnt ochre" of the solar disk in the panel in which God lets there be light can now be seen (after) as "bright as a burning furnace with its clear yellow glow, dark reddish core, and imperceptible circular beams of green." I have little reason to deny that he has in fact gotten closer, through cleaning, to Michelangelo, artist and man, if the artist were primarily a colorist and the man primarily interested in getting the look of objects right—as if Michelangelo were a kind of Impressionist and this were a work by Monet under restoration. How little Colalucci did pay attention to "Michelangelo, artist and man," emerges when he describes the sequence of famous images that line the central vault. "Michelangelo painted the scenes on the Sistine ceiling in reverse order—that is, he started with the *Deluge* and finished with the first day of Creation." In other words, he began with the end of the narrative, and ended with its beginning. But Michelangelo did not start, nor does the sequence end, with the *Deluge*. He started, and the sequence of nine episodes ends, with the *Drunkenness of Noah*. The *Deluge* is second in the order of creation and eighth in the order of the tremendous narrative which *Creation* begins. It shows how Mannerist an artist Michelangelo was when he began his immense undertaking. Dropping this work from his own narrative, Colalucci makes it difficult to follow Michelangelo's own stylistic evolution, and even more his own plan—after all, he decided upon what was to be the last panel before he painted any of the other episodes.

Colalucci's sentence stopped me in my tracks: nine and a half years, brushstroke by brushstroke, and the chief restorer gets the beginning and the ending wrong! It seems to me that if you get the sequence wrong you could get everything wrong, however convincing the sun may now be. And I felt a sense of waste and loss and even tragedy in this victim of a misconceived ideal of objectivity. The misconception lies in the faith that objectivity is a matter of brushstroke by brushstroke, inch by inch. But in fact this agenda is hostage to an interpretation of Michelangelo as a very different kind of painter than there is reason to believe he was. There is a famous reductionist claim by the Nabi painter Maurice Denis that "a picture, before being a battle horse, a nude woman, or some anecdote—is essentially a plane surface covered with colors assembled in a certain order." My sense is that this defines precisely Colalucci's attitude toward the painting he pretended to have rescued from "the muddy veil which was suffocating it." Get back to the spots of color, and the meaning will take care of itself!

I want to pause here and consider the fact that there are no "plane surfaces" in the Sistine ceiling. The space was built to the dimensions of Solomon's temple as described in 1 Kings—its length twice its height and three times its width. The temple was itself modeled on the tabernacle whose exceedingly exigent architect was God himself, since it was to be his dwelling place; and the tabernacle was a kind of tent, which (in my view) is alluded to in the complex curvatures of Sixtus IV's vault. It has the complex geometry of a canopy. The original decoration was suitably the

blue sky dotted with golden stars, which gives the sense of look-
ing upward through a kind of opening to what Kant called "the
starry heavens above." Pope Julius II wanted a more "modern"
decoration, and we know that Michelangelo exploited the curva-
tures in his articulation of the motifs he painted. He transformed
the ceiling from an illusion of the open sky to an illusory piece of
architecture, with a mock ceiling, supported by illusory columns.
You can't, after all, hang paintings on the *sky!* And he found ways
to illuminate the curved spaces with images.

To what degree did these curvatures contribute to the images
themselves? This would not have been a question for Maurice
Denis, who painted on flat canvases. As canvases, purchased at
art supply shops in Paris, were invariably flat, flatness was never
something with which images could have interacted. Images
might interact with edges, but not with surfaces, which were al-
ways more or less the same. But this was not the case with curved
surfaces, as we shall see—though it took some time for Michel-
angelo to recognize the possibilities the curvatures presented. His
exploitation of these figured prominently in the appreciation of
Michelangelo's achievement by his contemporaries.

Consider the figure of Jonah, which does not belong to the
narrative of the ceiling but is painted in the style of the last epi-
sodes Michelangelo painted (though the earliest in the narrative
order). Jonah is placed just over *The Last Judgment,* in a space
bounded by two pendentives, on what is the concave surface of a
truncated spherical triangle. If we think of the space abstractly, it
would be a shaped canvas in three dimensions, somewhat simi-

lar to certain pieces by Ellsworth Kelly. Michelangelo shows the prophet leaning energetically back in this triangular alcove, and what astonished Michelangelo's peers, like Condivi, was that "the torso that thrust inward is on the part of the ceiling closest to the eye, and the legs that thrust outward are in the most distant part. A stupendous work, declaring how much knowledge there is in this man in the faculty of drawing lines in foreshortening and in perspective." There is a contradiction, in effect, between physical surface and the pictorial illusion, which led Vasari to regard the panel with Jonah as the "culmination and epitome" of the great ceiling. Could Jonah be struggling to free himself from the ceiling, to struggle free of the physicality of the ceiling as the bound slaves struggled free from the stone, to come, in effect, to life? I don't think a brushstroke by brushstroke procedure can answer that question. In my view, it can be answered only with reference to an interpretation—a piece, really, of inferential art criticism. I shall argue that it should be answered negatively.

Meanwhile, I draw attention to the fact that color plays no role to speak of in Condivi's description. What I mean to underscore is that foreshortening and perspective are attainments of drawing primarily, augmented by the effect of chiaroscuro, the "art of design, dark and light," which, though certainly attainable in painting by adding amounts of black to a given hue, is in no sense an attainment of color as such, but of values of colors, which goes with shading and highlight. But secondly, Condivi was a sculptor, as Vasari was an architect, and both were sensitive to the handling of real three-dimensional spaces. Would this even be visible from

the floor? Maurice Denis's maxim epitomizes a modernist posture, begun by Manet, whose canvases were described by Zola as "an ensemble of delicate, accurate *taches*" (House, p. 75). Monet internalized this ideal in 1890, the very year of Denis's declaration, in his advice to an American student, Lilla Cabot Perry: "When you go out to paint, try to forget what object you have before you, a tree, a house, a field or whatever. Merely think: here is a little square of blue, here an oblong of pink, here a streak of yellow, and paint it just as it looks to you, the exact color and shape, until it gives you your own naive impression of the scene before you." Zola added to his characterization "from a few steps back, [the taches] give a striking relief to the picture." Michelangelo had nothing before him. The *interplay* between surface and image was too intricate and complex to imagine that he could have painted it the way Lilla Perry would have painted a house by a tree, following Monet's instruction. Contrary to Denis, the painting was first Jonah, and then the brushstrokes. We have to ask what the image meant before we can even think of the pigment.

I draw attention to Jonah mainly because the energy of the figure makes it as good a candidate for someone struggling out of darkness as we are likely to find in the ceiling's population. Jonah's proto-Baroque figure really does look as if it is struggling, as indeed it is, since he is being disgorged by the somewhat ornamental fish, and has truly come from the darkness of "the belly of the beast" into the light. As restored, the light feels like the pale light of dawn, not dissimilar to the light into which Christ arises from the dark of the sepulcher in Piero's *Resurrection*. The paral-

lel with Christ's resurrection was intended, and it is why Jonah is represented in the first place. I feel that it would have been inconsistent with the meaning of resurrection to have had Jonah-Christ come into a second darkness—the metaphysical darkness the Neoplatonist reading requires. But if this is true in the case of Jonah, it would be even more true of the other figures in the ceiling, who are not represented as engaged in struggle at all, such as Jonah's pendant, Zechariah, stationed at the other pole of the axis that bisects the ceiling longitudinally, and shown in profile, reading a book, with a pair of angels reading over his shoulder. We have to pay particular attention to the complex framework within which the figures and scenes depicted are set. The ceiling is divided into spaces by heavy, painted frames—as if the whole ceiling were a sort of picture gallery articulated into distinct if related episodes. An overall darkness would not make sense. It might make sense with *The Last Judgment,* where there are none of these divisions but masses of figures driven by spiritual winds, and caught up in postures of ecstasy and agony, exultation, and despair, and where light and darkness might signify damnation and salvation. The ceiling implies a uniform illumination which goes with the illusion of an overhead picture gallery, allowing Michelangelo to use darkness and light *within* the pictures, in whatever way the individual episodes narratively require, without having, in addition, to totalize the episodes into a single feeling which the prerestorational darkness implied. Each picture has its own space. The common space belongs to the pictures, not their subjects. So one feels that a bit of interpretation would have

assured S. Colalucci that he might proceed with impunity. It is precisely against an interpretation based on meaning that any argument in favor of retaining the darkness has to collapse. He may not have proceeded any differently, had he understood this, but he could have justified what he had done in ways the procedures themselves were unable to do. In truth, the critics were as positivistic as the restorers. They too treated the work as a physical object. But an artwork is an embodied meaning, and the meaning is as intricately related to the material object as the soul is to the body. Michelangelo created a world as well as an object, and one has to try to enter the world in order to see what parts of the physical objects are relevant. The hole in the roof has a story, but not a meaning that belongs to the work.

The overall sense of the ceiling today is that of a decorated expanse, the color scheme of which is now pretty continuous with what one sees elsewhere in the Vatican, in rooms and corridors surrounding the awesome chapel, and decorated around the same time that it was. My sense is that for just these reasons, the colors were invisible to Michelangelo's contemporaries, simply because they were the colors anyone would have expected in a "modern" space, and did not stand out. Indeed, had the ceiling looked the way it looked before the recent restoration—looked the way many of us remember it—it *would* have been remarked upon by those contemporaries. It would have looked like a subtly colored but largely monochrome drawing. But I speculate that just because the colors were consistent with cutting edge interior decoration circa 1508, nobody especially paid them great at-

tention. What they saw, as witness the testimony of Condivi and Vasari, was the powerful drawing and the antinomies between the two modes of being a picture—the one mode physical, and very much what Denis had in mind by colors assembled on a surface, the other pictorial and astonishing—and then the interaction between these modes, as in the great *Jonah*. Viewers—or the ones Michelangelo would have been concerned about—were perhaps far less interested in color than in the virtuoso way in which image and space were handled, as in the great Jonah. The question for me was what role the color played in their experience of the chapel, and I tentatively conclude: none. And from that perspective, nothing much would have been lost had the ceiling in fact been monochrome, except that its contemporaries, with their decorative expectations, would have been baffled. Goethe, in 1786, stunned by the great work, wrote, "If only there were some means of fixing such pictures in one's soul! But at least I shall bring with me all the engravings and drawings after his work that I can find." There were no such things as color reproductions in 1786, but in my view the inevitably monochrome reproductions, in black or sepia or sanguine, would have given Goethe most of what he wanted and needed (there had been three restorations before Goethe was overwhelmed by Michelangelo's "grandiose vision"). Michelangelo had protested at the time of his commission that he was not really a painter, and I think he probably meant this. Here is how Vasari, his greatest admirer, describes the work in his life of Michelangelo: "Every beholder who can judge of such things, now stands amazed at the excellence of the figures,

the perfection of the foreshortenings, the astonishing round-ness of the outlines, and the grace and flexibility, with the beau-tiful truth of proportions which are seen in the exquisite nude forms here exhibited; and the better to display the resources of his art, Michelangelo has given them of every age, with varieties of expression and form as well as of countenance and feature" (Vasari, 259).

Nowhere in Vasari's expansive commentary is there any men-tion of the great use of color, though in describing the first sibyl he notes that Michelangelo had been "anxious to show that the blood has been frozen by Time," which may or may not have re-quired color. So what Goethe wished to remember would have been adequately served by the excellent engravings on sale at the *calcographica*. This is a striking confirmation of a curious view of Descartes, that so far as objective representation is concerned, engravings can depict "forests, towns, people, and even battles and storms" without resorting to color, regarding the objective reality of which he had great doubts, as did most seventeenth century philosophers. According to Veronique Foti, "The Royal Academy, founded less than two decades after Descartes's death, remained thoroughly Cartesian in its conviction that, in painting, color, as a purely sensory element, must be subordinated to ra-tional considerations." I suppose they had in mind perspective and composition—the geometry of space. I am not sure that fore-shortening belongs to this list, as it appeals precisely to truths about the eye.

Still, the cleaning did make things more vivid, most especially

the complex illusionist architecture that frames the various images, which are, for reasons I shall consider in a moment, really pictures of pictures. I mean that they are doubly illusory: there are the illusions *in* the pictures, and the illusions *of* the pictures. It is, in this sense, like those paintings of collections of paintings, commissioned by collectors in the next century. It may strike us as odd that the illusion requires that paintings be *hung on the ceiling!* But Michelangelo was the most visionary of Mannerist architects. In his Laurentian library, for example, he transferred a volute from ceiling to floor and turned it into a sort of buttress, giving it a giant dimension. So why not treat the ceiling as a wall? The cleaning makes clear the fact that those are pictures of pictures by giving a certain clarity to the framing apparatus.

Whether it was that or the political atmosphere we in the nineties breathed, I noticed certain things that I had never paid attention to before I was prevailed upon to enter the chapel again, and see with my own eyes what had been achieved. In contemplating the nine pictures in the ceiling's narrative, from the *Creation* to *Noah's Drunkenness,* what struck me was the fact that the central picture—central to the narrative, dividing it in two, and corresponding to the longitudinal center of the chapel itself—is the *Creation of Eve.* It fits the feminist cast of our vision today that in some way the creation of woman is the controlling event in the great story. God has separated light from darkness, created the heavens, divided the waters from the earth, and fashioned man from a handful of dust. Those are four episodes, and in the fifth God summons woman into being by a gesture of his hand while

Adam sleeps. That is the fifth episode. Then there is the *Temptation* and the *Fall*, the *Sacrifice of Noah*, the *Deluge*, and finally Noah lying stone drunk on the floor, to the consternation of his three sons. What strikes me is that God is in every picture through the creation of woman, and absent from every picture after that. It is as though there is a definite break in the order of things. Once woman is there, history begins. Before that there was simply cosmology, governed by a kind of anthropic principle. After that, sex, moral knowledge, piety, flood, inebriation. Had the narrative ended with the *Deluge*, it would, as destruction, have corresponded symmetrically to *Creation*, but that would have seemed pointless, a mere doing and undoing. In some way it is important that it end in *Noah's Drunkenness*. That proves the futility of the flood as a way of beginning all over again. A new kind of intervention is required, given the reality of the human material. That has, I think, to be understood if we are to understand the story, which is what alarmed me when Colalucci got the sequence wrong.

I have, I must confess, not seen it anywhere said that the great climactic event, which divided the period of cosmology from the period of history, was the creation of the human female. Mainly this is because scholars read the nine panels in a different way— as a triplet of triplets—with the central triplet the creation of man and mankind's fall, with three scenes of the creation of matter on one side and, on the other, three scenes of the emergence of—I quote from Howard Hibbard—"a new chosen man, Noah." Well, it is true that God "chose" Noah—he after all did not choose but made Adam—and he did so because, though "God saw that the

wickedness of man was great in the earth, and that every imagina-
tion of the thoughts of his heart was only evil continually" (Gen-
esis 6:5), Noah "found grace in the eyes of the Lord" (Genesis 6:8)
because he was "just, and perfect in his generations, and walked
with the Lord" (Genesis 6:9). God drowned everyone else as a
botched job. So what does it mean that the story ends with Noah
dead drunk and naked by the wine barrel? Drunkenness was not
in itself sinful, save that it led Noah to expose himself, hence
exposing others to the danger of seeing his nakedness—a kind
of danger Noah's sons respond to by backing in and covering it.
Nakedness, of course, means specifically genital exposure, which
can have a shattering, if ill-understood, significance even today,
and it is an interesting question whether this will be dissolved
as male frontal nudity becomes more and more commonplace
onstage and on-screen. That will certainly obscure for us the shat-
tering significance it has in Genesis, since Ham, the son who sees
his father's penis, even if by accident, knows he is to pay a terrible
price: the other two sons back into the paternal presence, eyes
averted, bringing Noah's cloak to cover not his nakedness but the
emblem and reality of his power: "Shem and Japheth took a gar-
ment, and laid it upon their shoulders, and went backward, and
covered the nakedness of their father; and their faces were back-
ward, and they saw not their father's nakedness" (Genesis 9:23).
Lucky for them: Noah cursed Ham—"a servant of servants shall
he be to his brethren" (Genesis 9:25). The sight of his nakedness
brings inequality into the world, and in consequence the reality of
politics in human life. In any case, something crucial would have

been lost in ending the story with the *Deluge,* whatever the meaning of this final panel.

Possibly Noah, drunk and naked, implies the ineradicable weakness of human beings—after all, Noah, who was regarded as the one worth saving, is in the end a bad lot. Catastrophes, if there is to be any human remnant, are insufficiently radical solutions to the problem of human badness, and only the miracle of salvation is capable of overcoming the sins of our endowed substance. So the story that begins with creation ends with the need to intervene in history in a new way, by God himself taking on the attributes of the flesh and being reborn through suffering. Still, there is Eve, midway precisely between creation and the revelation through weakness of humanity's hopeless condition. She would certainly not have had that central position if there were four episodes before her creation, and only three episodes after, as Colalucci's description implies. Something as momentous as creation must be entailed by the last episode, and that would be God's sacrifice of his son as a means to redeem sullied humanity from eternal damnation.

Meyer Schapiro wrote that medieval readers saw the "Ave" uttered by the Angel of the Annunciation as "Eve" written backward, as though Mary reversed the act of her sister. So Mary and Eve would be reverse and obverse of the same moral being. And the coming into being of woman engendering a history in which nothing is finally changed in the human material is reversed by Mary, through whom history is placed on a heretofore unimagined plane. Hibbard writes, "*The Creation of Eve* is crucial for the

whole decoration." There is another consideration. If Eve is midpoint, this makes the end points especially salient. The first panel is *Creation,* and the mid-panel Eve, which makes Noah drunk an odd choice for the last panel unless—Noah and Christ are one in the same way Eve and Mary are one. He is sinful humankind. So Noah points to a future which lies outside the narrative panels entirely, reminding us that there has to be some reason why the narrative panels are surrounded by prophets (seven) and sibyls (five), identified through the fact that they foretell the future. And finally, using Eve as midpoint, the last four panels form a certain unity in that Noah's nakedness is connected to the discovery of nakedness through shame in the *Fall* and the *Expulsion*—the first panel after Eve's creation.

It is just here that the restorer, with his view of objective neutrality, cannot speak, but neither can he pretend to have gotten "close to the artist and the man." The artist and the man told a story through painting the ceiling, and we have to read the story to know why he painted the ceiling the way he did. Or: we have to seek access to his mind through projecting interpretative hypotheses as to the meaning of the work, since the artist never divulged his program. Which, if either is true, has to be settled in part by art criticism, in part by art history. For my immediate purpose it does not matter how we come out. The main thing is that there is no reading without interpretation, though one can, with the restorer, be passive and simply let one's eyes register the brushstrokes and take in the fiery sun and the silvery moon. But *that* is hardly what Michelangelo as "artist and man" is all about.

73

Saint Augustine argued, on the basis of some curious evidence, that in Paradise there was no such thing as sexual passion. He thought that Adam possessed full control over his body, including the genital apparatus, and that he did not have to be aroused in order to plant a seed in his consort's womb. There would have been no such thing as sexual temptation in Paradise, so the serpent had to find another path to Eve's weakness. With the knowledge imparted by the forbidden fruit, passion entered the human mind, and passion caused us to do what reason would have counseled us against. Human history—the history from which God is absent—is the history of passions. The penis is the emblem of that, an unruly member over which we have imperfect control. To perceive Noah's nakedness is to perceive his all too human weakness. It is that of which Adam and Eve were ashamed. Frederick Hart, an art historian, writes of the "total and explicit male and female nudity" in Michelangelo's ceiling, "unprecedented and unfollowed in Christian visual narrative, thus declaring the essential purpose of the instruments of *generation* through which the will of the Creator is fulfilled." I don't see that, especially, once again, because of the significance of Noah's genital nakedness and its consequences for history. I cannot see it as connected to divine intention, but as thwarting it, forcing God to have recourse to an entirely new way of dealing with the fateful flaw in his handiwork. If Hart were right, there would be as many female *ignude* in the spaces outside the narrative as there are male *ignudi*—twenty-two in all.

But there aren't any females at all.

How are we to deal with this garland of *jeunes hommes en fleur*? I very tentatively offer the thought that they emblematize a higher form of love than the fleshly love embodied in the panels. It will not perhaps go down easily to claim that homosexual love has deep affinities with Christian love, except that what we call Platonic love, between two men, can have nothing to do with generation, and so allows the possibility of love transacted on a higher moral plane. The ancient conception of friendship, discussed so deeply by Aristotle, was possible only between members of the same sex, and while this has very little to do with gay sex, as we understand it, orgiastically, today, it must be remembered that the humanists of Florentine culture were Platonists through and through—and it was for them that the ceiling was finally painted. It was the story of the rise and transcendence of sexual passion, and the glorification of the kind of love Christ allegedly had for humanity, in which, again, generation played no role. So Platonism comes into the interpretation, after all, but in ways having nothing to do with what was mere dirt—matter confused as meaning.

As a philosopher, I would cherish an argument which demonstrates that the mind cannot be mapped onto the brain any better than the Sistine ceiling can be mapped onto the brushstrokes—and that Eliminativists are as misled as Colalucci. It would be great if the analogy itself were accepted, even if we did not know where to go from there.

THE BODY IN PHILOSOPHY AND ART

> Life without a feeling of bodily organs
> would be merely a consciousness
> of existence, without any feeling of
> well-being or the reverse, i.e., of the
> furthering or the checking of the vital
> powers. For the mind is by itself alone
> life . . . in union with its body.
> —Immanuel Kant, *Critique of Judgement*

It has twice happened to me that a piece of philosophy which I was developing about the body seemed to have a significance very different from that which had engaged my interest in the first place. The result in both instances was somewhat comical. In the 1960s, for example, I got involved with the philosophy of action. I was interested in working out the differences between two kinds of action—actions we perform by doing something else, which causes the first action to happen, and actions we simply perform, without first doing something through which the intended actions happen. Turning on a light by manipulating a switch and propelling a billiard ball by striking it with a cue stick

are examples of the first kind of action. Moving one's fingers or winking one's eyes are examples of the second. I called these latter "basic" actions, and we are all endowed by nature with a certain repertoire of basic actions, through which we do these and various other things. Some people are impaired—they cannot move their fingers, say—and some are specially gifted—they can, to take a trivial example, wiggle their ears. These differences somewhat correspond to cognitive impairments, like being unable to see, and to cognitive gifts, such as clairvoyance, in which certain people know things in some direct way that others don't (if you ask these so-equipped individuals how they know something, they say they just do). I developed these parallel structures systematically and published my results in my 1973 book, *Analytical Philosophy of Action*. I don't propose here to discuss these ideas further other than to say that when I announced a graduate course in the philosophy of action at Columbia University in the late sixties, I was astonished by the throngs that turned out for the opening session. It made no sense to me—until I realized that the students were very excited by the idea of such a course because they thought it must be about the philosophy of political action. Those were revolutionary times in universities, and here was a philosopher ostensibly talking about what was closest to students' hearts. I never saw so many bored, disillusioned people in my life when I explained that I was interested in such simple performances as raising eyebrows or raising body temperatures. The distance between such preoccupations and the overthrow of capitalism—or the military-industrial complex—was simply too distant for those

bent on changing the world to have much patience with distinctions I by contrast found enthralling. A philosopher who was then a student recently recalled me standing in front of a blackboard covered with logical structures.

The second time something like this happened was when I published a collection of essays in a book I called *The Body/Body Problem*. The title made an oblique reference to a well-worn but eternally unresolved topic in philosophy, the so-called mind/body problem, and I originally presented my views to an academic audience at Columbia in the 1980s. When this book was published in 1999, however, "the body" had become a kind of hot topic in our cultural dialogues, largely in consequence of gender studies, queer studies, and theoretical feminism, not to mention the considerations of privacy that underwrote a woman's right to abortion—topics that were hardly visible when the original lecture was delivered. My book was all at once felt to have a topicality I had never intended, especially since by that time I had acquired a certain reputation as a writer on art. For example, I was invited to be the keynote speaker at the twenty-eighth annual conference of the Austrian Association for American Studies, to be held at the University of Klagenfurt, addressed to "the various fixations within contemporary American culture, on the body." The organizers of the conference cited not only *The Body/Body Problem* as evidence of my expertise, but the fact that I had published a long study on the photography of Robert Mapplethorpe. I found exceedingly comical the idea of an elderly gentleman, whose body showed no obvious dedication to weight lifting or marathon

running—or even dieting—turning up in Klagenfurt to address earnest scholars on late twentieth century American concerns with the body. It was an act of charity to everyone involved that I declined the invitation.

But I did begin to receive invitations from various art programs, and though the interest that artists had in the body came from concerns rather different from those of the philosophers of my generation, the distance between them was not quite so insuperable as that which separates crooking a finger and the revolutionary overthrow of colonial oppressors. It is a fact that questions of gender, for example, had played no role to speak of in the philosophical discussions of the body I had addressed in the body/body problem, whereas they have become obsessively addressed by contemporary artists such as Matthew Barney or, earlier, Judy Chicago. And it is also true that philosophers of a later generation, particularly those upon whose thought feminism had had a major impact, were attempting to take up issues of gender in a fundamental way. These philosophers were much closer to contemporary artists in this regard than they were to the philosophers I had been addressing in *The Body/Body Problem*. My analysis had been offered as a way of narrowing the gap between the body as philosophically construed and the body as artists have come to think about it—and perhaps it was time that philosophy began to take up the kinds of issues that even the earnest students of Klagenfurt had decided to devote a summer institute to. So for better or worse I decided to accept some of these invitations, and to see what I might say that would help all of us, artists and

philosophers alike, in thinking more clearly about our embodied condition. This chapter is a product of that decision.

It strikes me, to begin, that our embodied condition has played a very central role in our artistic tradition, mainly because visual artists in the West had the task of representing the mystery on which Christianity, as the defining Western religion, is based— the mystery, namely, of incarnation, under which God, as a supreme act of love and forgiveness, resolves to be born in human flesh as a human baby, destined to undergo an ordeal of suffering of which only flesh is capable, in order to erase an original stigma of sin. This entire vast narrative was revealed, and the artists were charged with the task of making it credible. In *Burlington Magazine* the great British art critic Roger Fry wrote in an article titled "*Madonna and Child* by Andrea Mantegna": "The wizened face, the creased and crumpled flesh of a new born babe . . . all the penalty, the humiliation, almost the squalor attendant upon being 'made flesh' are marked." Babies are pretty messy entities, and it is a tribute to Mantegna that his Christ child exhibits some of what mothers and fathers put up with when they are obliged to deal with a living mass of appetites and demands that a baby consists of at first. Even God, once God decided it was crucial to become enfleshed as a human, must begin life as helplessly as we all begin—hungry, wet, soiled, confused, colicky, crying, dribbling, babbling, drooling—and needing to be fed, changed, washed, and burped. The image of Jesus as a baby, naked and showing the unmistakable mark of gender which the noted art historian Leo Steinberg restored to consciousness in his book *The*

Sexuality of Christ, has been as much a staple of Western art as has the image of Christ stretched, bleeding, and in a state of utter agony at the terminus of his life. It had, for reasons internal to Christian thought, to be a suffering death—Jesus could not, for abstruse reasons, simply die in his sleep, a smile on his face, surrounded by his disciples—like Buddha, say—just as it had to be a real birth through which God entered the world as an enfleshed being, between the legs of a human mother. The whimpers of god and of a baby are indiscernible, though the difference between them is momentous.

This past Christmas I was listening to a service of carols at Riverside Church, near where I live in New York, and I was struck by words in an unfamiliar carol. The first verse says: "A child, delivered on a stable floor. His mewing, newborn cry is all that God can say of hunger, thirst, and aching need." And in the penultimate verse it says, "A man, in dying moments on a cross. His God-forsaken cry is all that God can say of searching, scarred, redeeming love." God, who is eternal, would have no conception of either hunger or pain—and would require physical embodiment to know what these mean. Through the incarnation, it is nevertheless God that is hungry, thirsty, and needy; and it is God that cries out in pain barely imaginable to those of us who have never undergone that order of extreme torture. Still, there would be no way in which one could tell that these were not the sounds of an ordinary human infant or an ordinary human victim of torture. Those almost animal sounds are the voice of God expressing himself as human. I suppose that when we think of the voice of

God, we think of it as disembodied, and coming from nowhere. But when we take incarnation literally, the voice of God cannot be told apart from that of an embodied human.

We all begin in the same way, and from the same place in the radical helplessness of universal babyhood. The philosopher Richard Wollheim notes in a remarkable passage in his book *Painting as an Art* regarding the art of Willem de Kooning:

> The sensations that de Kooning cultivates are, in more ways than one, the most fundamental in our repertoire. They are those sensations which give us our first access to the external world and they also, as they repeat themselves, bind us forever to the elementary forms of pleasure into which they initiated us. Both in the grounding of human knowledge and in the formation of human desire, they prove basic. De Kooning then crams his pictures with infantile experiences of sucking, touching, biting, excreting, retaining, smearing, sniffing, wallowing, gurgling, stroking, wetting.
>
> And these pictures . . . contain a further reminder. They remind us that, in their earliest occurrence, these experiences invariably posed a threat. Heavily charged with excitation, they threaten to overwhelm the fragile barriers of the mind that contained them, and to swamp the immature, precarious self.

The world itself, on Wollheim's extraordinarily vivid account, as encountered by the infant, is as plastic as a lump of clay given

form, if we can speak of form at all, by the way the infant engages with it. The world as we first encounter it—and we encounter it immediately with our fingers and mouths and viscera—is very different from, to use a somewhat unfair example, the world of classical physics—an integrated mathematical system involving relationships between mass, length, and time. But babies, in Western philosophy in contrast with Western theology, have played no role to speak of at all. The early empiricists supposed there must be a path from simple sensations to the concepts of science, and it is somewhat miraculous that if we indeed begin as Wollheim claims we do, that we can arrive at an ability to understand classical mechanics in perhaps a dozen years. By contrast with acquiring a natural language, however, the acquisition of classical physics seems no miracle at all. The baby of a student of mine was born deaf, and as a philosopher the student and her husband agonized about how their child would ever acquire language with no auditory input to speak of. But it is widely appreciated that on the basis of the most degraded input, children construct a correct grammar, and, in truth, when I met her baby, at age two and a half, she was able to ask me whether I cared to have some wonton soup. Writers like Locke did not begin quite so viscerally as Wollheim proposes, but rather with the so-called five senses, but my overall sense is that even if the content of neonatal experience is as Wollheim's psychology describes it—a stew of smells, hurts, warmth, resistances, and givings way—there is probably an innate endowment of structure that enables us very quickly to give some common form to the experience and not merely to wallow in it. But I cite Wollheim's visceral phenomenol-

ogy because if there is anything to his account at all, the foundations of our knowledge of the external world presuppose having begun with the kind of body Mantegna's painting depicts and de Kooning's implies.

On one occasion in which I presented Wollheim's thoughts, a colleague in cognitive science showed me a striking video. In it a man is holding an infant ten minutes old. The man opened and closed his mouth, and the baby, imitating him, opened and closed its mouth. The man stuck his tongue out and the baby stuck its tongue out. The mimeses were so exact and unpremeditated that it seemed almost as though the baby and the man were playing one of Wittgenstein's language games, albeit without words—as if by opening his mouth the man was issuing a command to the baby to open its mouth. And if one reconstructed the inferential structure that connects persons and mouths, babies must come into the world with impressive computational powers, and a language of thought that gets them to reason that they must stick their tongues out when others do.

But his video contrasts so vividly with Wollheim's words that we must infer that the latter uses the word "knowledge" as the Bible does, when it speaks of Adam "knowing" Eve. It may be a good, even inspired, interpretation of de Kooning's brushwork, but in psychology it is limited to the way two lovers passionately explore one another's bodies, or the baby palpates its mother's breasts. Where is the threat that Wollheim speaks of? If one has read at all widely in Wollheim, you will realize that he is presupposing a psychoanalytical account that meant a good bit to him, where the

baby in the video is already ten minutes into life, learning by imitation to be a human like the rest—learning what gestures mean.

In contrast with Western art and Christian theology, there are no babies to speak of in Western philosophy. Philosophers in the seventeenth and eighteenth centuries wrote about human understanding, human nature, and human knowledge—but they did it from the perspective of pure reason, regarded as our default condition. The genius of the Christian religion is that however beyond our grasp its essential mysteries are, a way was found, especially through art, to translate them into terms everyone understands, in situations in which we have all participated through the fact of having been babies and having grown up under a caregiver. I mean the primordial image of Western art is that of mother and child. In *Ulysses*, Joyce speaks of "the word every man knows," and scholars have wondered what word Joyce had in mind. Was it, scholars have hoped, the word "love"? My sense is that the word would have to be invariant to all languages, and that probably it would be "Ma-ma"—two repeated syllables that together reenact the motion the lips make in sucking. Since Vasari we have thought of Western art triumphalistically, as the conquest of visual appearances, construed in terms of space, shape, and color, with the discoveries perspective and foreshortening as high moments. But this could all have been worked out in terms of figures in a landscape. The truly astonishing history rather has to do with representing human beings through their inner states—suffering in the crucifixion, hunger in the Christ child nursing, and, above all, love in the way the Madonna holds the Child. This was

a discovery of Fra Angelico, who juxtaposes a Madonna and Child with an Egyptian Isis and Osiris, between whom there is not the slightest sign of love. Fra Angelico represents persons in ways that are to be understood only with reference to their inner states. These inner states are human universals, but they do not turn up, for deep cultural reasons, in other artistic traditions—certainly not, for example, in classical art, however beautiful, and certainly not in African art, however powerful. The astonishing thing about Western art is that we are entirely at home with it. The Nativity is an entirely familiar scene, with the baby, the mother, and the father (somewhat out of it), and with friends and family admiring the new baby, some of them bringing presents. We all know more or less what everyone is feeling, and in a general way what everyone is doing and why. And we know this because we know the way the body expresses these entirely commonplace feelings.

It is exceedingly instructive to juxtapose the great philosophical work of René Descartes—his *Meditations,* published in Paris in 1641—with paintings of that period, a Nativity, say, or the simple painting by Descartes's countryman Nicolas Poussin, of *The Holy Family* (Detroit Institute of Arts) and painted in that exact year. The latter shows the Madonna playing with her baby, while warming something in a porringer from which she will feed him—he is in the process of being weaned. Saint Joseph is shown leaning against the windowsill, maybe catching a few winks, having been kept awake by Jesus's yowling during the night. We know exactly what everyone is thinking and feeling. Nothing, of course, tells us that the Holy Family is holy—that is for the eye of faith. Even to

begin to know what it means for them to be holy, one has to have internalized a fairly complex metaphysical narrative, beginning with disobedience and sin, and the knowledge we have of good and evil. But Christian artists managed perfectly to show how the personages in the holy family were human. There is a difference between knowing that the Madonna and Child are happy and that they love one another, and knowing that the Madonna is free of sin and the chosen vessel of the Holy Spirit. Both may involve inferences, but the former inference is of a kind we make every day of our lives without thinking about it. We learn this, so to speak, on our mother's knee. We spontaneously respond with love to the look of love. So much is happening in a mother's face when she feeds or nurses her child that the meaning of love is conveyed in the first moments of interaction between them. That, I think, is the kind of thing that Wollheim means to get across to his readers. I have read somewhere—what a dangerous experiment!—that if the person providing food wears a mask, the child will not eat. I think this would be true even if it were a smiling mask—a "happy face," for example. So much depends upon the infant's immediate knowledge of the mother's feeling and expression. So many facial muscles are involved in the look of nurturing and love! There seems hardly room for being mistaken, though logically of course it is possible that we are mistaken.

Descartes begins with the fear of being mistaken, of being deceived by some kind of evil genius who bends his every effort on getting us to make mistakes. It is like a duel between man and the devil. Can I defeat the demon? Is there any way to cognitive tran-

quility? Can I be certain of anything whatever? The answer is yes. If I am always mistaken, I must at least be thinking that to be the case that is not. Only someone who thinks can be wrong—and if someone is always wrong, he must always be thinking. So a person cannot be wrong about the fact that he thinks, however wrong he may be in what he thinks. Suppose I am wrong about this. Then I am thinking that I am not thinking—and so I must be thinking after all! The one thing I cannot think away is thinking. So I am—I must be—what Descartes terms a "thinking thing," a *res cogitans* in my essential nature. I can, easily enough, think that I do not have a body! Nothing follows from the fact that I think that I must have a body to do the thinking with! I can deny that I have a body—and I may be wrong but I won't be wrong in the same way as when I think that I am not thinking. So I may have a body or may not. But I must be a mind if I am wrong. *Sum res cogitans.* The thinking self is logically distinct from the body. That is Descartes's view. Here is the argument in a nutshell: I cannot intelligibly doubt my own existence, since doubting is a form of thought, and if I think I am. But I can intelligibly doubt that I have a body. Hence I am not identical with my body. Hence I can logically exist bodiless.

Distinct means distinguishable: the mind is distinguishable from the body, and logically independent of it. One has the sense that for Descartes, this was a powerful idea: it meant, in more traditional terms, that the soul is independent of the body, which is a kind of logical argument for the possibility that the soul can survive separation from the body, hence an argument

for immortality. It is worth emphasizing that this need not have been quite such glad tidings as Descartes may have thought. The church strongly believed in bodily survival: Christ bodily survived death, and ascended to his Father's side in his bodily condition. We are allegedly rejoined to our body on the day of judgment. The church was not interested in a heaven of bodiless spirits flitting about. I mention that again to emphasize how central the body was to religion—it is certainly central to Islam if you consider the promises of a fleshly paradise made to suicide bombers—when philosophy, as in the case of Descartes, could in effect write it off.

What did he write off? The body as conceived of by Descartes was not the body in Poussin's world or in our own, so far as our common experience goes. It is a machine—a kind of statue with moving parts, more complex than a watch, but only by matter of degree. It is through the motions of its various parts that Descartes proposes to explain how this machine performs its essential functions—walking, eating, breathing, and the rest. Descartes undertakes to describe the body in such thoroughly mechanical terms in his *Traité de l'homme* in 1664. All these functions, he says in the end, follow naturally from the disposition of our organs, no more and no less than the movements of a clock—or some other automaton—"follow from the movement of wheels and balances." It is all perfectly mechanical and due, he argues, to the "heat of the fire that continually burns in the heart, which is in no sense different in nature than the fire we encounter in inanimate bodies." The steam engine was not to be invented for another century—but there is little question that had he known about it,

Descartes would have used it as a model for representing the way we operate. The history of thought about the human body has pretty much been the history of such models. In the seventeenth century the available models were clocks. In the eighteenth and nineteenth centuries they were self-regulating mechanisms like steam engines. Today the models are based on computers. No one can tell today what tomorrow's technology will yield by way of models for understanding the bodily processes. So the understanding of the body has been by and large metaphorical, and in consequence of technological progress we know immensely more than the ancients knew or could have known about the body. Aristotle would have had to do some serious catching up if he were to come back to earth: his knowledge of the body is hopelessly out of date.

On the other hand the body as represented in art would have been—would indeed be—entirely accessible to him. He would have had no difficulty whatever in knowing what is going on in Poussin's painting of the Holy Family, just as we have no difficulty in understanding the way people in *The Iliad* and *The Odyssey* behave, or in the Greek tragedies. He would have had no difficulty grasping what goes on in Picasso's Blue Period paintings. He would have had some trouble, perhaps, with Cubism—but what did Picasso paint but men and women and things to eat? When we read Aristotle on digestion or on color, we have nothing to learn. Neither have we anything to learn when we read him on the emotions, as in his writings on rhetoric. But the reasons are very different. We have nothing to learn from him on digestion be-

cause his views have been totally superseded. We have nothing to learn from the rhetoric because nothing much has changed. The human material today is just as it was in ancient times, just as it was in the age of Poussin. And the same is true of Descartes. His physiology is dated in a way in which Poussin's physiognomy is not: human nature is still the way Poussin depicted it. Of course, the body has not changed over the two and a half millennia since Aristotle. But the knowledge of the body has changed so that it would be difficult to believe that Aristotle, Descartes, and your standard medical textbook of today are talking about the same thing. But this is not true for poetry and painting. We cannot really have better knowledge of human beings than we get from Homer and Euripides, or from Poussin or early Picasso. It is this disparity that I referred to in the concept of the body/body problem. These days, of course, painters are trying to use science to paint human beings. The art dealer Max Protetch sent out a Christmas card of his family, painted by someone who paints DNA. It is a picture which shows his DNA as well as the DNA of his partner, Heather, and their two children. Of course, Aristotle would have had no idea of the Protetch family from this! No one can tell very much about what people are like from their DNA! But I won't follow this line further here.

Descartes's picture of mind and body is easily caricatured by saying that he represents us as ghosts in machines, and there is little question that his thesis of the logical independence of mind and body, on the one side, and his highly mechanistic view of the body, on the other side, certainly seem to support such a view. But

his view is really more complex than that, and it is worth talking about at some length. In the sixth (and final) *Meditation,* he somewhat surprisingly asserts that "I am not in my body the way a pilot is in a ship," when his thesis of the logical independence of mind from body would have encouraged us to believe exactly that. No: Descartes wants to say that we are at one with our body, that we and our body are indissolubly commingled. His thought is that a pilot knows only by inference that his ship has been damaged— the ship begins to list, or has sprung a leak, or whatever. By contrast, when our body has been damaged, we feel it directly: we feel pain, or we feel dizzy to the point where nothing resembling thought can take place in the soul. Naturally there are damages to the body we don't feel: we do not know that we have high blood pressure through feeling anything, we learn it only through the reading of an instrument. Or that our glucose levels are unacceptably high. But Descartes is thinking about certain fundamental cases in which we know immediately that our body has suffered injury—the way, to return to babies, the infant cries when it is hungry, thirsty, wet, or colicky. And we know that something like this has happened when we hear the baby cry, though we may not know which thing. The baby is not in its body the way it is in a carriage. The baby does not cry when there is a hole in the carriage.

It is the mind as embodied that Descartes attempts to explain, however crudely, in the *Traité* of 1664. He really is interested in what takes place in an embodied mind: passion and desire, the sensations of sounds, smells, tastes, and thermal changes—the bodily sensations Wollheim describes. He is interested in waking

and sleeping, which go only with embodied minds. And of course there are problems, a major one of which is discussed with a brilliant image some decades later, in 1714, in Leibniz's *Monadology*. It takes us to the heart of the mind/body problem:

> It must be confessed that perception and that which
> depends upon it are inexplicable by mechanical
> causes, that is, by figures and motions. And suppos-
> ing there were a machine so constructed as to think,
> feel, and have perception, we could conceive of it as
> enlarged and yet preserving the same proportions,
> so we might enter it as into a mill. And this granted,
> we should only find on visiting it, pieces which push
> one against another, but never anything by which
> to explain a perception. This must be sought for,
> therefore, in the simple substance and not in the
> composite or in the machine.

Leibniz then argues that perception is in what he terms the "simple substance" but not in the machine. And this really is a kind of ghost-in-the-machine theory.

The image of entering the body the way one enters a mill is exceedingly vivid. Technology has evolved in such a way that we can enter the body, optically at least. While I was writing this, I underwent procedures for kidney stones—an exceedingly painful condition. The stone was visible by means of a CAT scan, and by fiber optic exploration through a catheter. The urologist could see the stone, and knew neuroanatomy well enough to see that

I was in excruciating pain. One could map the path, from the nerves upon which the stone was impinging through the whole neural network, and one could infer that I must be in pain. One could, in a manner of speaking, see the pain. But seeing and feeling are very different sensations: one can see the way a feather moves across the sole of the foot—but one will not, through the visual pathways, feel the tickling sensations the feather creates. Think of the most intimate physical relationship there is, that of sexual intercourse. We have entered/surrounded one another's bodies. But what the other is feeling is a mystery as old as we are. No matter what the behavior is of the sexual other, we want to know whether it was "good" for them. We know what we feel. But what the other feels is a matter for doubt: remember Meg Ryan's feigned orgasm in *When Harry Met Sally*.

We are at the heart of the mind/body problem here, and Leibniz is unquestionably right in saying that we do not see the perception of the person whose body it is that we have "entered." The perception is experienced only by that person, the one who feels pain or tickling—or ecstasy—and this is what Descartes would have meant in part in speaking of the way we are intimately bound up with our body. "I feel your pain" is sympathetic nonsense. When Jesus cries out "Let this cup pass from me" (Matthew 26:39), he knows there is no way this can be done. The entirety of the Christian drama requires that God himself suffer in the body of his Son the terrifying agony of dying on the cross. It cannot be done for him.

I think, details aside, that Descartes has probably carried the

matter as far as it can be carried. Why the perturbations of nerves should be perceived as pain or tickling by the person whose nerves they are is a mystery. It is the mystery of nervous tissue. Imagine that we walk into an actual mill, and we see the millstones pulverizing the grain between them. Someone might say: if this were a human body, we might imagine that the one whose body it is could be in pain. Is the mill undergoing an agony that we cannot feel? Is it like bone crushing against bone when the cartilage is gone and someone needs a hip replacement? You can think one way or the other. The sound the stones make could be the groans of a being in agony—or they could just be the sounds the stones make when they grind against one another. Such speculation is not entirely idle, since it does raise the question of whether there are bodies other than those we possess, the owners of which—if there are owners—can have the kinds of perceptions we have. If not, then Descartes and the being he describes in *Traité de l'homme* are the beings with the kinds of feelings the figures in Poussin's painting show—the feelings that are so transparent to us, however little we know of what goes on in their bodies to make those feelings possible.

I want now to pick up Descartes's idea of the logical independence of mind from body, which has an application today that it would not have had in the seventeenth century, and to which our somewhat clumsy speculation on whether the mill is in agony has a certain bearing after all. Until relatively recently, the only beings we knew to be capable of thought had the kind of nervous tissue that defines the human body. Descartes was convinced that

nervous tissue was not the whole story, since he refused to believe that animals had minds or were capable of thought or even, if you can imagine, that animals even felt pain. (When we plunge lobsters into boiling water today, we like to say that they don't feel anything.) Kant spoke of rational beings—which included us, but also included "higher beings" like angels—and though there was some speculation about the kinds of bodies angels possessed, there would have been a question of whether they felt pain or even pleasure of a physical sort. But the question took a new direction when it began to seem that computers were capable of thought, and the idea suggested itself to philosophers that mental processes were multiply realizable: that thought could be a brain activity or a computer activity, and thinking realizable in neurons or in microchips.

Philosophers and nerds of every persuasion have obsessed on the issues of multiple realizability, centering around the question of whether machines can think, play chess, and the like—whether artificial intelligence is intelligence. On these matters there is a vast and inconclusive literature, and I do not propose to embark upon it here. The question for me is not whether machines can think, but what thoughts they can have, and it seems to me clear that they could not have thoughts about the body that presuppose the embodied condition Descartes speaks about in the sixth *Meditation* and the *Traité de l'homme*. I don't mean to say that there are not "language games" a machine can master involving what we may call the language of the body. The machine can say "I have a headache," and we say "Is it something you ate?,"

and the machine says that no, it is due to stress and we say the machine ought to relax and the machine asks how, with so many responsibilities, it can do that. This is like pretending. Machines do not have headaches, do not eat, do not have stress, cannot take vacations. To understand these idioms one has to have a body like the body we all have. One has to be human. One has to be like the personages in Poussin's paintings, and to belong to, to use the title of a famous exhibition of the 1950s at the Museum of Modern Art, *The Family of Man.*

When I wrote the *Body/Body Problem,* at the end of my discussion of the Sistine vault I alluded to a philosophical position called Eliminativism. In effect, it held that the language we use to describe one another, keyed to the body language painters have used, is based on what the authors of the position called folk psychology, and that it is hopelessly out of date. In effect, they said, we are to use a language based on what we might encounter when we enter Leibniz's mill—the language of the body we perceive when we see the shuttle back and forth of nervous impulses. And my thought was that there are the two bodies, the body as encountered upon entering it through incision and dissection as well as by X-ray, MRI, and various other modes of medical imaging, and the body of folk psychology, which expresses anger and grief and the like. If we eliminated folk psychology, we would have no idea of the meaning of what we encounter in the body. If we eliminated what science tells us, we would have no idea of how these meanings are possible.

The body that feels thirst and hunger, passion, desire, and love.

The body that we understand when we read the ancients describing men in battle, men and women in love and in grief. The body, I would say, that our artistic tradition dealt with so gloriously for so many centuries, and somewhat less gloriously in a certain kind of performance art today.

THE END OF THE CONTEST

THE *PARAGONE* BETWEEN PAINTING

AND PHOTOGRAPHY

> The art of painting has died, as this
> is life itself, or even something more
> elevated.
> —Christian Huygens, looking
> through a camera obscura in 1622

The *paragone*—Italian for "comparison"—was used in the Renaissance to claim the superiority of one of the arts over the others. Leonardo, for example, drew up a paragone between painting and the other arts, like poetry, music, sculpture, and architecture. The upshot was that painting emerges as superior to all the rest. The whole point of the exercise was to enhance the circumstances, social and material, of actual painters like Leonardo himself. In a way, painting was in fact the dominant art in New York when the Abstract Expressionists flourished, and while I know of no paragone that was argued in their usual hangout, the Cedar Bar—painters versus sculptors, say—there was an undeniable attitude that women were not suited to practice this

art. Women took this as a truth, and when they began to study art in a serious way, the question focused on what arts were suitable to their sex. Needless to say, women and perhaps their male supporters vilified painting so that, in the seventies, sculpture and photography were acceptable for women, and painting for men— but painting lost the glamour it had. Today, of course, art is not neatly divided, and it is difficult to imagine that collage outranks installation, and that performance outranks both. But there was a fairly long paragone in the nineteenth and early twentieth centuries between photography and painting. No one can say that this will have been the last paragone in the history of art, when that history is intertwined with the history of politics, but it differed from the typical paragone, in which the terms of the comparison were forms of art, but there was some lingering resistance to classing photography as an art. This seems to have been settled rather quickly in France, where photographs were shown for the first time in the 1857 Salon, along with painting and sculpture— the daguerreotype had been invented in 1839—whereas Alfred Stieglitz still felt rejected as an artist in 1917. There is no record of photographs being rejected in the 1917 exhibition of Independent Artists, held in New York, notorious mainly for having rejected Marcel Duchamp's *Fountain* (see chapter 1). The exhibition was modeled on the French Society of Independent Artists, which committed itself to the principle of no jury and no prizes, to forestall another *Salon des Refusés* and its fiercely exigent jury of 1863. So whether photography was one of the fine arts was still moot in America when the First World War broke out and at which

time Stieglitz closed his gallery. I think it was considered moot by philosophers when it had been settled by art museums: a collection of Stieglitz's photographs was acquired by the Albright-Knox Art Gallery in Buffalo, New York, in 1930, and the Museum of Modern Art proclaimed its modernity by establishing a department of photography in 1940, curated by Edward Steichen. But as late as 1958 William Kennick could still suggest to a philosophical readership that photographs were a borderline case of artworks. This is doubtless because the range of photographs go from a yellowing snapshot of Aunt Sadie and Uncle Al on their honeymoon at Cedar Point, to Andreas Gursky's 99 *Cent II, Diptychon*, which sold for $3,340,456 at Sotheby's in 2008. So perhaps the complication did not arise immediately in France, since the photograph in question would have been an early daguerreotype, probably pricier than the average miniature hand-painted portrait by some artisan, albeit on ivory.

The paragone was instantly conceded when the painter Paul Delaroche, on first learning of Louis Daguerre's invention, supposedly said, "As of today, painting is dead." No one, so far as I have been able to determine, has established that Delaroche actually said this nor knows, accordingly, what he did say. Delaroche was a major history painter, when history painting was still considered the most prestigious genre of painting by the various academies of art, so as he practiced it he was scarcely threatened by photography, inasmuch as most of the events he depicted took place in the past, and he was more interested in telling a good story than in depicting the past *wie est eigentlich gewesen*—the way

it actually took place, to use von Ranke's famous definition. Thus Delaroche depicted in 1833 the execution of Lady Jane Grey as taking place in a dungeon, contrary to the historical record. This option for painting was to become central in the ensuing paragone between painting and photography from 1839 until about 1930, when the paragone ended and photography was grudgingly granted the status of art. What Delaroche would almost certainly have had in mind was that it is simply irrational for human beings to have to learn to use instruments like pencils and brushes to create pictures of the world when a portrait or landscape surpassing what most artists could achieve in realistic conviction could be produced by clicking a shutter—requiring no skill at all. Such was the attitude of William Henry Fox Talbot, the co-inventor of photography, who simply wanted souvenirs of sites he was not up to drawing for himself, and so he invented a way for nature to draw itself—hence "the Pencil of Nature," as he called it. Obviously there is more to the matter than clicking a shutter. A daguerreotype is a mirrored metal plate, coated with silver halide particles deposited by means of iodine vapor. An image is projected, which sets up a chemical process, and the image is fixed after an exposure of some seconds. Moreover, there is something uncanny in the way a complete likeness could form on a metal plate with a daguerreotype. This technique is magic in the further sense that it captures detail invisible to the naked eye, unlike Fox Talbot's photography, which uses paper negatives.

In this sense the superiority of the camera over the hand-and-eye method of representing connects with a tradition that had

more or less vanished with the Renaissance. The tradition is brilliantly tracked by Hans Belting in his masterpiece, *Bild und Kult,* where the kinds of pictures people were interested in were made not by an artist's hand but by mystical intervention, as in the case of Veronica's Veil, where Christ's perspiring face appeared by magical transfer, as was believed to be the case with the Shroud of Turin. And of course there was also the portrait of the Virgin that Saint Luke—with skills the Virgin knew were not up to the task—set out to paint, so she, through a miracle of tenderness, permitted her likeness to form on his panel, which of course resembled her perfectly. That is what I believe Saint Luke is demonstrating in the wonderful painting by Guercino—not his painting, but something the Virgin brought about, so lifelike that the angel in the painting has the illusion that it is tangible. The image is internally related to the Virgin, the way a mirror image would be. The Virgin is present in the image, so you are directly praying to her in praying to the picture, and there is accordingly the possibility that the wishes could be granted. Possibly the "portrait" itself is an answered prayer of Saint Luke. In any case, to say that you would have thought it was done by a camera is, in effect, to say, it looks as if nature painted itself, as if the artist had nothing to do with it. It takes great skill to make your painting look like photography.

Delaroche generously helped get a government pension for Daguerre, whose real achievement, in his own mind, was his other invention, the diorama (he took up photography only because he thought it might help in creating improved dioramas). Delaroche

wrote in his 1839 recommendation to the government on behalf of Daguerre that "Daguerre's process completely satisfies all the demands of art, carrying essential principles of art to such perfection that it must become a subject of observation and study even to the most accomplished painters." With this, we can begin to construct the paragone, which consisted in photography's boast that it was, more than painting, able to show how things really look when produced in a way that cannot be bettered. The rather obscure American Pre-Raphaelite painters William Mason Brown and John William Hill are good examples of this. I became interested in them because Russell Sturgis, the *Nation*'s first art critic and one of the founders of professional art criticism in the United States, thought the future of American painting lay with them, and not with the art being turned out by the members of the American Academy of Design. Like the British Pre-Raphaelite Brotherhood, which had secured the endorsement of John Ruskin, England's leading art critic, they believed in what they called "visual truth." Ruskin wrote in the *London Times* in 1851 that, since Raphael, artists had sought to "paint fair pictures rather than stern facts," but that these artists were resolved to paint only what they see "irrespective of any conventional rules of picture making." The highest compliment the American Pre-Rafs, as they called themselves, could pay one another was that one would have thought, looking at their work, that it had been made by a camera, which raised the question, I suppose, of why not just use the camera, instead of painstakingly painting what the camera achieves without effort. The camera, presum-

ably, showed only what the eye sees and nothing more. Hence it had to set the criterion of visual truth. Its relevance to art was to show what visual truth was in any given instance.

It struck me only recently that nineteenth century painters must have believed that visual truth was defined by photography, however alien to human vision what the camera reproduced often was. A good example of this would have been Eadweard Muybridge's photographs of horses in motion. Painters decided that Muybridge's images showed what horses really look like when they run, and in effect copied Muybridge's photographs in their paintings of horses, even though that is not at all the way we see horses when they run. We really don't see animals move the way Muybridge shows them moving, or else there would have been no need for the photographs in the first place: Muybridge hit upon his awkward but seemingly authoritative experiments that were really designed to answer such questions as whether all four of a horse's hooves ever touch the ground at the same time—in other words, phenomena the human eye could not perceive. Muybridge's published images had an impact on artists like Thomas Eakins and the Futurists, and especially on Edgar Degas, who sometimes portrayed a horse moving stiff-legged across the turf, exactly the way it can be seen in Muybridge's photographs, but never in life. Degas, who took up photography himself, would have argued that the photographs teach us how we must see, even if the images look quite unnatural. This confuses optical truth with visual truth. Muybridge mocked Victorian painters, whose depictions of horses racing were visually far more convincing

than his optically correct photographs could have been. They showed horses stereotypically.

Another example is portraits. Most of what the human face shows is not so much the kinds of physiognomic expressions— grief, joy, anger—that academic artists had to master in order to show in narrative paintings how persons felt, but transitions between expressions. With a film speed of ASA 160 and shutter speeds of one-sixtieth of a second we could now capture the face appearing in ways which the eye never sees—"between expressions," as it were. That is why we reject as not "really me" many of the images on a contact sheet, which don't look like what we see in the mirror. The result is that faces are defamiliarized by the camera, as in the typical portrait by Richard Avedon. What it really amounts to, with the modern camera, is that the photographer is stopping movement, hence making stills, with results that never arose or could have arisen with painted portraits. (Degas's horse is a three-dimensional still.) The still shows "optical truth" but it does not correspond to perceptual truth, namely how we see the world stereotypically. I first realized this when I saw Avedon's photograph of the philosopher Isaiah Berlin, who was a friend of mine. The picture in no sense captured how Isaiah looked to anyone who knew him, but shows instead an unrecognizable and invisible sourpuss. It is, moreover, false to say that he "sometimes" looked like this. He never looked like this to the eye. He did so only to a camera set to ASA 160, F22 at one-sixtieth of a second—which of course one does not see. The camera shows, on this view, the eye's limitations. It shows how things would re-

ally look if we could but see them the way the lens does. So you can take a shot from a contact sheet in the confidence that it really shows the real as it is, better by far than the false image of a smiling subject asked to "Hold it! Hold it! That's it!"

These ideas came home to me vividly when I was thinking about Edouard Manet's painting of the execution of Maximilian, done in five versions, from 1867 to 1869, shown together in John Elderfield's great didactic exhibition at the Museum of Modern Art in May 2006. There was no photograph of the event, since that was forbidden by the Mexican authorities. Manet depended on newspaper accounts, and the details kept changing as the reports came in. At first, Manet supposed that the execution was carried out by Mexican guerillas, and he painted the firing squad wearing sombreros. Gradually, it became known that the firing squad was made up of Mexican soldiers in uniform—though far more tattered, as we know from a contemporary photograph, than Manet's final and official version shows. It all at once occurred to me that Manet was seeking to show the event the way it would look if it had been photographed. He painted it just at the moment when the muskets were fired—there is smoke coming out of their muzzles—and one of the victims being executed at the same time as Maximilian is depicted falling to the ground, fatally wounded. Photography was not yet capable of recording events happening this quickly—the Leica was not to be invented until the next century. Film was too slow, exposure times were long. But certain things peculiar to the photograph appear in the way the painting is organized.

In the brilliant essay "Abstract and Representational"—a sketch of the history of what he designated Modernism—the critic Clement Greenberg wrote in 1954:

> From Giotto to Courbet, the painter's first task had been to hollow out an illusion of three-dimensional space. This illusion was conceived of more or less as a stage animated by visual incident, and the surface of the picture as the window through which one looked at the stage. But Manet began to pull the backdrop of the stage forward, and those who came after him . . . kept pulling it forward, until today it has come smack up against the window, blocking it up and hiding the stage. All the painter has left to work with now is, so to speak, a more or less opaque windowpane.

No one else, as far as I know, described the shift from traditional to Modernist representation in these terms, nor would anyone else have credited Manet with having begun the Modernist program in quite this way, but I find it a very clarifying approach, however much I otherwise differ from Greenberg. The question for me is what explains this momentous reconception of pictorial space on Manet's part, and what I want to do is conjecture that it was the effect of photography, which most will grant is the truly revolutionary invention in the history of representational technology in modern times.

Greenberg is famous for saying that the defining essence of

the medium of painting is flatness, which means, in effect, the denial of the illusory space that was a necessary condition for the great creative achievement of painting "from Giotto to Courbet." It was this observation, whatever its problems, that encouraged Greenberg to propose that Modernism began with Manet. What is needed to put these two thoughts together into a causal narrative is the recognition that photography played an operative role in the transformation of art from traditional to modern. What, after all, could have been more modern than the photographic camera, with its ability to fix images, which until then were ephemeral and fleeting, as in the camera obscura? The camera shortened depth—"brought the background forward"—and flattened forms, largely, I think, because the lenses of the period were often telescopic, which showed things closer together than they would look to the eye—almost on top of one another. In a way, the firing squad looks like it has physically placed the muzzles of their guns much closer to the victims than they are. We see this today in watching baseball games on television—the camera of necessity is at a distance requiring telescoping, which puts the pitcher and the batter on top of one another. Manet's Maximilian painting was inspired by Francisco Goya's *El Tris de Mayo* (*Third of May*), which also shows an execution and which Manet saw on a trip he made to Madrid. But the camera did not exist in 1808 when Goya painted his execution scene. The distances are not distorted in the name of visual truth.

Manet also tended to suppress transitional tones, which emulate the way the frontally illuminated object in a photograph

drives the shadows to the edges, inevitably flattening forms, an effect which Manet seized upon in painting his portraits. Greenberg writes that "for the sake of luminousness Manet was willing to accept this flatness" (*The Collected Essays and Criticism: Clement Greenberg*, vol. 4, 242). A further truth is that the lenses tended to give a forward central thrust to the image, as in Manet's *Gare Saint Lazare,* in which everything is crowded into the foreground. I would wager that Manet's painting owes a lot to discussion with the photographer Nadar, in whose studio the first Impressionist exhibition took place in 1874. The camera made Modernism happen.

Honoré Daumier created a wonderful caricature of Nadar in a balloon over Paris. Nadar was the first to do aerial photography, using balloons, and had a clear sense of what happens in telephotography. Daumier titled his picture *Nadar Elevant la Photographie à la Hauteur de l'Art,"* which is a joke—"Nadar elevates photography to the level of art." My conjecture amounts to substituting Manet's name for Nadar, and reversing the terms. The irony of Greenberg's theory of flatness, set forth in his 1960 essay "Modernist Painting," is that it was supposed to rest on the reduction of the medium of painting to its essence—which turns out to have been an artifact of another medium altogether, namely photography. So much for the purity of media that was meant to be the foundation of his theory of criticism. My conjecture is that Manet imitated the camera by painting as if visual reality were artifacts of the photographic processes at the time.

Coincidentally, the Museum of Modern Art simultaneously

mounted two shows—one of Manet's *Execution,* in which we can look for signs of the beginnings of Modernism, and the other of Brice Marden, beginning with his gray-in-gray monochromes, which I saw as the end of Modernism as a period style. They are exactly gray in gray, with shadowy markings of darker gray that had served other painters, such as Jasper Johns or Alberto Giacometti, as backgrounds against which they painted the objects or figures that carried the primary interest of their works. Marden seems to have brought them forward to coincide with the surfaces of his paintings, making his surfaces his subjects, turning his paintings into objects. The history of Modernism is the history of narrowing the space between background and foreground, just as Greenberg says—a progress in which important stages are Cézanne's tipping the surface of his tables up toward the viewer, creating the kind of space the Cubists exploited, especially in their collages; the American trompe l'oeil paintings, in which flat objects like newspaper clippings and paper money are pinned or pasted on flat surfaces, enabling painters to eliminate shadows and thus to short-circuit depth. Then there is the inevitable flattening with Paul Gauguin and the Nabis, who prioritized decoration and adopted the highly decorative format of art nouveau, as in the case of Vincent van Gogh, whose work borrowed, in addition, the flatness of forms in the Japanese woodblock print. The Pre-Rafs, in attempting to emulate the camera, had also eliminated depth, almost in the way that happens when one looks at an object through a microscope.

So one can trace the Greenbergian narrative of Modernism

from Manet to Marden as the triumph of flatness over illusion-
ist space, culminating in the triumph of two-dimensionality over
three-dimensionality. But the paragone followed a more zigzag
path. The painter might concede the camera's superiority in cap-
turing visual truth. But Delaroche could have argued that paint-
ing's superiority lies in its not being tethered to dull old truth.
Painting could create its own truth. Nature's pencil simply traces
what is set before the lens, without creative imagination. The pho-
tographer can represent only what is there, whereas the painter
is free to use his imagination and show things in ways other than
how they are or were. Thus the liberties Delaroche took with his-
torical truth. The painter selects the moment at which to repre-
sent an event, as in *The Execution of Lady Jane Grey*, where the
victim is blindfolded and begins to search in a kind of panic for
the executioner's chopping block. It is a very cruel painting. She
wants a swift, clean death and pleads with the axman to give her
that. Delaroche paints the straw that will soak up Lady Jane's
blood and receive the head. But for effect he sets the scene in a
dungeon rather than outside on a scaffold. In another painting he
shows Roundhead soldiers blowing pipe smoke in the face of King
Charles. He treats painting fictionally. Photographers were not
slow to show that they were quite capable of doing the same with
a camera lens and hence should be considered artists, if that were
the criterion. The Victorian photographer Henry Peach Robinson
hired actors, constructed an emotional scene, and photographed
it, as in *Fading Away*, the dying moment of a young woman. Peach
Robinson's compositions have influenced Jeff Wall's large backlit

photographs, in connection with which "Is it art?" has little purchase. With the advent of Impressionism, photographers showed ways in which they could achieve something of its effects through soft focus, coated lenses, and heavy paper. But Stieglitz was still stuck with the wide refusal to consider photography an art, despite Delaroche having granted it that status in his letter of support for Daguerre's pension. Fortunately, the controversy became irrelevant when Modernism made it irrelevant—when it stopped being important to win contests with cameras. Wall exhibits the Postmodernist—post-Greenbergian—thesis that whatever works is OK. Wall's inspiration to use backlighting came, after all, from bus stops.

Meanwhile, it is clear why photography was denied the status of art, mainly through the fact that everything that seemed to make painting an art was subtracted from what we may as well call pictography: for manual skill you needed nothing more than the ability to push a button or squeeze a bulb. That meant that the hand was as pictographically irrelevant as the foot. All that was needed now was to make the eye irrelevant, which brings us back to Duchamp, who reinvented the concept of art, making both hand and eye, as well as aesthetics, irrelevant to the *definition* of art. It is in the spirit allowing us to make art out of bus stop advertisements that I want to conclude by discussing one more use of the camera, namely in the photographic silk screen in the 1960s.

The silk screen print went particularly well with what one might think of as Warhol's personal philosophy. "I think it would

be so great if more people took up silk screens so that no one would know if my picture was mine or somebody else's," he said in 1963. Thus, according to the authors of Warhol's catalogue raisonné, "Not only did [Warhol] deflect those who would attempt to know his work or to discern his hand in it, he disputed the role of the artist as the author of a work of art." He also "challenged art connoisseurship as a way of knowing objects through their visual characteristics" (Danto, *Warhol*). Since there is no "touch" by means of which anyone can tell whether a given silk screen is his or, say, Gerard Malanga's, the artist's hand, like the artist's eye, plays no role to speak of in the work of the Factory. Warhol literally stopped drawing from 1963 to 1972.

The first big project of the Silver Factory years was making the facsimiles of Brillo shipping cartons and their lesser companions for the April 1964 show at the Stable Gallery, which made an immense impression on me. That show would have been unthinkable without silk screen: the boxes were made with stencils from photographs of the top and four sides of the Brillo box, for example, and then ink was pressed onto the sides of fabricated plywood boxes through the mesh, turning out replicas of actual shipping cartons.

My philosophical preoccupation with contemporary art began when I visited that exhibition. I more or less accepted that the boxes were art, but immediately wondered what the difference could be between them and the real Brillo cartons of the supermarket, which resembled them visually. The question was not whether one could tell the difference, which was an epistemologi-

cal question, but rather it was what made them different, which is what philosophers call an ontological question, calling for a definition of art.

The great thing about the sixties was the dawning recognition that anything could be a work of art, which was something evident in all the main movements of the time—in Pop art, Minimalism, Fluxus, Conceptual art, and so on. What accounted for the difference? The big mantra in the art world was Frank Stella's sullen "What you see is what you see." But there was not a lot of difference between what you see when you see a *Brillo Box* by Warhol and the Brillo boxes designed by James Harvey for the Brillo people to use for moving their products about. So: why weren't they artworks if Andy's Factory-produced boxes were? I have answered this in my first chapter, so what I want to do now instead is to marvel at the way in which the camera helped give form to the philosophical question that had been kicking around for a few millennia, "What is art?," and to explain why the photography-painting paragone had to be the last paragone. By the time Duchamp and Warhol had left the scene, everything in the concept of art had been changed. We had entered the second phase in the history of art, broadly considered.

KANT AND THE WORK OF ART

Although Immanuel Kant's *Critique of Judgment* is incontestably the great Enlightenment text on the aesthetic values of that era, dealing as it does with taste and the judgment of beauty, it must for that reason seem to have little to say about art today, where good taste is optional, bad taste is artistically acceptable, and "kalliphobia"—an aversion to if not a loathing for beauty—is at least respected. Clement Greenberg claimed that Kant's book is "the most satisfactory basis for aesthetics we yet have." It may have been true for Modernist art— but Modernism, as a period style, more or less ended in the early 1960s, and the great movements that succeeded it—Fluxus, Pop art, Minimalism, and Conceptual art, not to mention all the art made since what I have called the end of art—seem beyond the

reach of Greenberg, let alone of Kant's philosophy of art. What Greenberg admired in Kant, or so I believe, would have been art that possessed what Kant distinguished as "free beauty," which is also possessed by certain natural objects, like some flowers, birds, and seashells. Kant mentions "decorative borders or wall paper, and 'all music without words.'" Had abstract painting existed, he would doubtless have situated some of it under "free beauty." True, Greenberg had little interest in natural beauty, but he thought one didn't have to know anything about the history of an artwork to know what is good, and that those who know what is good are certain to agree with one another—even if no one can put what makes art good into words. All this agrees quite closely with what Kant says about free beauty.

But Kant had two conceptions of art, and his second theory of artworks cannot support his reasons for taking up judgments of beauty in the first place, namely the parallels they suggest with moral judgments, and their universality, which made beauty, he thought, the symbol of morality. Late in *Critique of Judgment* he introduces a new concept—the concept of *spirit*—which has little to do with taste, nor does it touch in any way the aesthetic of nature. Taste, he now writes, "is merely a judging and not a productive faculty." When we speak of spirit, on the other hand, we are speaking of the *creative power* of the artist. Asked what we think of a painting, we might say that it lacks *spirit*—"though we find nothing to blame on the score of taste." Hence a painting can even be beautiful, as far as taste is concerned, but defective through lacking spirit. Put next to Rembrandt, almost any Dutch

painting will seem without spirit, however tasteful. Since taste has little to do with spirit, Kant is feeling his way out of the Enlightenment here, and edging toward what Hegel says in his *Lectures of Aesthetics:* "Taste is directed only to the external surface on which feelings play," and "So-called 'good taste' takes fright at all the deeper effects of art and is silent when externalities and incidentals vanish." At the beginning of his great lectures on aesthetics, Hegel sharply distinguished between natural and artistic beauty: artistic beauty is "born of the spirit and born again." Kant, as one can tell from the examples I cited, includes both certain natural objects as well as certain kinds of art. So Kant's second conception of art is of another order than the view of art as an aesthetic object, beautiful in the way natural objects are beautiful.

In his book *Italian Hours* Henry James writes that Baroque painter Domenichino is "an example of effort detached from inspiration and school merit divorced from spontaneity." That made him, James goes on to say, "an interesting case in default of being an interesting painter." There was nothing wrong in Domenichino's work. He had mastered the curriculum of the art school. But spirit is not something learned, and there is no remedy for its lack. Saying that Domenichino's work lacked spirit, accordingly, is criticism of an entirely different order from the usual art school crit. It is not Domenichino's fault, merely his tragedy, that he does not possess what Kant calls "genius"—"the exemplary originality of the natural gifts of a subject in the *free* employment of his cognitive faculties." I had better note that spirit in his view *is* inter-

nally connected with the cognitive faculties. It is that, I shall wish to argue, that connects Kant to contemporary art or, better, to art of every historical period, ours included as a matter of course.

But let's stay with Domenichino for a moment. He was a Bolognese artist who followed the Carracci to Rome and helped execute the agenda of the Council of Trent, which hoped the power of images might counter the Reformation. His Saint Cecilia frescoes of 1615–17 were regarded as the apogee of painting, according to Wittkower. Poussin regarded his masterpiece, *The Last Communion of Saint Jerome,* as the greatest painting of its age, barring only Raphael's *Transfiguration.* During the eighteenth century he was "often classed second only to Raphael." Two of their paintings were on the short list singled out for rendition to the Louvre by Napoleon's troops. He "created a landscape style which was to have an important influence on the early work of Claude." His style was Classicist, and he stood out as such in contrast with the Baroque style enthusiastically adopted by his rival, Lanfranco. The decline of his reputation in the nineteenth century was due almost entirely to John Ruskin, the Hilton Kramer of his time in terms of critical vehemence who was driven to diminish the Italian School to make room for modern paintings, in the book so named. My hunch is that Henry James got his views on Domenichino from reading *Modern Painters,* rather than from prolonged critical contemplation. In disparaging Domenichino in the 1840s, Ruskin wrote that seventeenth century paintings lacked sincerity, and that the Bolognese school was based on eclecticism.

This was a historical misunderstanding: the Bolognese prided themselves on being "eclectic," meaning: they took the best of everything.

There was another element in the rivalry between Domenichino and Lanfranco—in effect the rivalry between Classicism and the Baroque: Lanfranco accused his rival of plagiarism, specifically in his alleged masterpiece, charging that Domenichino had stolen the idea from their teacher, Agostino Carracci. A contemporary, Luigi Lanzi, who admired Domenichino, wrote that he was not as great in invention as he was in the other parts of painting, and for that reason often took from others, even the less famous. So he was an imitator—but "not a servile one" (14). What he stole was Agostino's idea but not the way he embodied it. The law holds that you cannot copyright an idea, so it is not theft when Domenichino paints Saint Jerome's final communion. To cite a modern example, Saul Steinberg was frustrated that everyone ripped off his famous *New Yorker* cover of the New Yorker's view of the world—a wonderful example of giving visual embodiment to a nonvisual truth. Steinberg got satisfaction, finally, when a judge ruled that the copying did not give everyone license to replicate Steinberg's spidery letters. The embodiment was his private property, even if the idea that only he was capable of creating was in the public domain, showing how New Yorkers map the world: there's New York, and then, secondarily, there's everyplace else.

It is striking that we find two of the same aspects in a seventeenth century altarpiece and a twentieth century cartoon—idea and embodiment—and that both are to be found in Kant's second

but not his first view of art. It turns out, more or less, that all Kant really has to say about his second view of art in his book is packed into the few pages given over to spirit, and its presence in perhaps the greatest Enlightenment text on aesthetics is itself a sign that Enlightenment values were beginning to give way, and a new era was making itself felt. It is a tribute to Kant's cultural sensitivity that he realized that he had to deal with Romantic values, and a whole new way to think about art, even if he was going to try to enlist them as largely cognitive. It is striking that in a very different part of Europe the same line was being argued by the artist Francisco Goya. In creating the program for the Royal Academy of San Fernando in Madrid, Goya wrote that there are no rules in art: *No hay reglas in la pintura*. That explains, according to Goya, why we may be less happy with a highly finished work than with one in which less care has been taken. It is the spirit in art—the presence of genius—that is really important. Like Kant, whose *Critique of Judgment* was published in 1790, Goya considered himself an Enlightenment figure—a *Lustrado*—so it is striking that both the philosopher and the painter felt that they must deal with post-Enlightenment views of art. But people were beginning to appreciate that something more was being promised by art than that it be in good taste. It was something that could transform viewers, opening them up to whole new systems of ideas. But there were no rules for achieving that, as there are for making something tasteful. It doesn't have a lot to do with judgment, to cite Kant's term. Imagine judging an art show the way you judge a dog show!

One feels that the Enlightenment is definitively over with when we read a work like Balzac's *Le Chef d'oeuvre inconnu,* published in 1831. The story involves three artists, two of whom are historical figures—Nicholas Poussin, as a young painter just starting out; Frans Pourbus, a successful Flemish painter, about to be replaced by Rubens as the favorite of Maria de Medici, Queen of France; and a fictional painter named Frenhofer, now an old man. They are discussing a painting of Marie, the Egyptian, shown removing her clothes, about to exchange sex for her passage to Jerusalem. Frenhofer offers to buy it, which flatters Pourbus, who takes this as a sign that the master thinks the painting good. "Good?" Frenhofer asks. "Yes and no. Your lady is assembled nicely enough but she's not alive." And he goes on:

> At first glance, she seems quite admirable, but look again and you can see she's pasted on the canvas— you could never walk around her. She's a flat silhouette, a cutout who could never turn round or change positions. . . . The thing's in perfect perspective and the shading correctly observed; for all your praiseworthy efforts, I could never believe this splendid body was animated by the breath of life. . . . What's lacking? A trifle that's nothing at all, yet a nothing that's everything.

Frenhofer now rolls up his sleeves and, with a few touches here and there, brings the painting to life. Frenhofer gives a natural reading of "lacks spirit" as "lacks life." That is the difficulty of reading Kant from the Romantic perspective that one might naturally

think he had opened up. In fact he has a very different and, in a way, a much deeper conception of spirit than that. Since spirit is central to the conception of art that he is advancing, we have to concentrate on the few works he actually discusses.

Kant speaks of spirit as "the animating principle of mind," which consists in "the faculty of presenting *aesthetic ideas.*" This does not mean: ideas about aesthetics. What it does mean is an idea presented to and through the senses, hence an idea not abstractly grasped, but experienced through, and by means of, the senses. This would have been an audacious and almost contradictory formulation in the classical philosophical tradition, in which the senses were regarded as hopelessly confused. Ideas were grasped by the mind alone, and knowledge was attained by turning away from the senses. To today's reader, "aesthetical idea" sounds exceedingly bland. To Kant's readers, it had instead to have been an exciting composite of contraries. At the very least, it suggests that art is cognitive, since it presents us with ideas, and that the genius has the ability to find sensory arrays through which these ideas are conveyed to the mind of the viewer. Hegel, in his *Lectures on Aesthetics,* has another way of putting it. He writes that art does this in a special way, "namely by displaying even the highest reality sensuously, bringing it thereby nearer to the senses, to feeling, and to nature's mode of appearance." And it "generates out of itself as works of fine art the first reconciling middle term between nature and finite reality and the infinite freedom of conceptual thinking." We can put this yet another way: the artist finds ways to *embody* the idea in a sensory medium.

Kant was never generous with examples, which he dismisses

in the First Critique as "the go-cart of judgment," the need for which "is a mark of stupidity." But I think we can get what he is attempting to tell us by considering the somewhat impoverished example he does offer. Imagine that an artist is asked to convey through an image the idea of the great power of the god Jupiter, and that he presents us with the image of an eagle with bolts of lightning in its claws. The eagle was Jupiter's bird, as the peacock was the bird of his wife, Juno, and the owl was the bird of his daughter Athena. So the artist represents Jupiter through this attribute, the way another artist represents Christ as a lamb. The notion of being able to hold bolts of lightning conveys an idea of superhuman strength. It is an "aesthetical idea" because it makes vivid the order of strength possessed by Jupiter, since being able to hold bolts of lightning is far, far beyond our capacities. Only a supremely powerful god is able to do something like that. The image does something that the mere words "Jupiter is mighty" are incapable of conveying. Kant speaks of ideas "partly because they at least strive after something which lies beyond the bounds of experience"—but they are *aesthetical* ideas because we have to use what does lie within experience in order to present them. Art, in his view, uses experience in this way to carry us beyond experience. In fact, this is the problem that Hegel finds with art relative to philosophy. It can't dispense with the senses. It can present ideas of great magnitude—but it needs "aesthetical ideas" in order to do so. Hegel's stunning thesis of the end of art is internally connected to that incurable dependence upon the senses. Philosophy's superiority, he supposes, is that it has no such need.

Let's consider a really great work of art, Piero della Francesca's *Resurrection*. There are in this tremendous painting two registers, in effect: a lower register, in which a group of soldiers, heavily armed, sleeps beside Christ's sepulcher; and an upper register, in which Christ is shown climbing out of his tomb, holding his banner, with what I feel is a look of dazed triumph on his face. He and the soldiers belong to different perspectival systems: one has to raise one's eyes to see Christ. The resurrection takes place in the "dawn's early light." It is, literally and symbolically, a new day. At the same time, it is also literally and symbolically a new era, for it is a chill day on the cusp between winter and spring. The soldiers were posted there to see to it that no one remove the dead body of Christ. The soldiers form a living alarm system, so to speak, set to go off by grave robbers. Little matter—Christ returns to life while they sleep, completely unaware. He does not even disturb the lid of the sepulcher. Though Christ is still incarnate—we can see his wounds—it is as if he were pure spirit. His language connects his extraordinary ideas with commonplace experience. The whole complex idea of death and resurrection, flesh and spirit, a new beginning for humankind, is embodied in a single compelling image. We can see the mystery enacted before our eyes. Piero has given the central doctrine of faith a local habitation. Of course, it requires interpretation to understand what we are looking at. But as the interpretation advances, different pieces of the scene fall into place, until we recognize that we are looking at something astonishing and miraculous. The gap between eye and mind has been bridged by "the middle term of art."

Kant was writing for audiences that had little, if any, knowledge of art outside the West. Presumably based on anthropological illustrations he must have seen, Kant was aware that there are parts of the world in which men are covered with a kind of spiral tattoo: "We could adorn a figure with all kinds of spirals and light but regular lines, as the New Zealanders do with their tattooing, if only it were not the figure of a human being," he writes in the *Critique of Judgment,* obviously thinking of tattooing as a form of decoration or ornamentation, as if the human body, made in the image of God, were not beautiful enough in its own right. It would have required considerable reeducation for Kant to have been able to think of the tattoo as a form of art, and hence as an aesthetic idea, connecting the person so adorned to invisible forces in the universe. Think of the popularity of the eagle as a tattoo, or a bosomy woman of Victorian dimensions.

What impresses me is that Kant's highly compressed discussion of spirit is capable of addressing the logic of artworks invariantly as to time, place, and culture, and of explaining why Formalism is so impoverished a philosophy of art. The irony is that Kant's *Critique of Judgment* is so often cited as the foundational text for Formalistic analysis. What Modernist Formalism did achieve, on the other hand—and Greenberg recognizes this—was the enfranchisement of a great deal of art that the Victorians, say, would have found "primitive," meaning that the artists who made it would have carved or painted like nineteenth century Europeans if they only knew how. African sculpture came to be appreciated for its "expressive form" by Roger Fry, and by the se-

vere Bloomsbury Formalist Clive Bell in his book *Art*. That meant that it was ornamentalized, in effect, like the tattoo, according to Kant. I often wonder if those who celebrated Kant aesthetics read as far as section forty-nine of his book, where he introduces his exceedingly condensed view of what makes art humanly important. One would have had to not so much widen one's taste, as Greenberg expresses it, but to come to recognize that African or Oceanic art is composed around aesthetic ideas specific to those cultures. When Virginia Woolf visited the exhibition of Negro sculpture that Roger Fry discussed with such enthusiasm, she wrote her sister Vanessa that "I dimly see . . . that if I had one on the mantelpiece I should be a different sort of character—less adorable, as far as I can make out, but somebody you wouldn't forget in a hurry." She meant, I suppose, that if she accepted the aesthetic ideas embodied in African figures, she wouldn't quite be the brittle Bloomsbury personage we believe her to have been, but instead would worship the fire god and dance to the beating of wild drummers (or Wall Street Occupiers) or in any case be responsive to the imperatives of a very different culture.

There is an exceedingly instructive confrontation of sensibilities in a particular unhappy episode in Fry's life. He traveled to France in the twenties to seek help for certain stubborn pains through self-hypnotic therapy. He met a Frenchwoman, Josette Coatmellec, with whom he formed a romantic though not, it appears, a sexual relationship. In spring 1924 he showed her an African mask that he had acquired. Fry's biographer, Frances Spalding, in *Roger Fry, Art and Life,* writes that "its savage ex-

pressiveness jarred on her nerves, leaving her frightened and alarmed." She badly misinterpreted Fry's gesture of sharing the mask with her—she thought he was taunting her. Before Fry could straighten her out, she shot herself, standing on the cliff at Le Havre, facing England. Fry designed her tombstone.

Part of the pluralism of our culture has been the widening of means available to artists to embody aesthetic ideas—to convey meanings—not easily expressed by means of Renaissance-style tableaux, which were ideal for the brilliant embodiment of ideas central to Christianity. Spirit drives them to find forms and materials quite alien to that tradition—to use, just to cite a material that is hardly to be found in art supply stores and that resulted in scandal a few years ago, elephant dung. In that same show that included Chris Ofili's controversial work, another artist, Marc Quinn, had sculpted a self-portrait in his own frozen blood. (It was important to the artist that the blood be his own.) Some years earlier Joseph Beuys began using animal fat almost as a signature material, emblematizing nourishment and healing, as he used felt to emblematize warmth.

Today art can be made of anything, put together with anything, in the service of presenting any ideas whatsoever. Such a development puts great interpretative pressures on viewers to grasp the way the spirit of the artist undertook to present the ideas that concerned her or him. The embodiment of ideas or, I would say, of meanings is perhaps all we require as a philosophical theory of what art is. But doing the criticism that consists in finding the way the idea is embodied varies from work to work. Kirk Varne-

doe, in his Mellon Lectures "Pictures of Nothing," presented a defense of abstract art: "We are meaning-makers, not just image makers. It is not just that we recognize images . . . it is that we are constructed to make meaning out of things, and that we learn from others how to do it." On this view, Kant's second view of art is that it consists of making meanings, which presupposes an overall human disposition not just to see things but to find meanings in what we see, even if we sometimes get it wrong, as in the case of poor Josette Coatmellec.

If this is a defensible reading of Kant's second theory of the art work, then, it seems to me, there is a certain affinity between Kant's notion of the aesthetic idea as a theory of art and my own effort at a definition of the work of art as an embodied meaning. Indeed, in a recent article I linked the two concepts in a way that might seem to imply that Kant has a philosophy of art that is closer to contemporary art than the Formalist reading of Kant, due at least to Clement Greenberg, however close that reading may have been to *Modernist* art. Indeed, Formalism appeared to its enthusiasts—the British Formalists Clive Bell and Roger Fry, as well as to Americans Greenberg and Alfred Barnes—to capture exactly what was Modern in Modernist Art. Certainly Formalism, whether entirely what Kant meant by it, did seem to have a more obvious connection to High Modernism—Abstraction, De Stijl, Henri Matisse—than to any paradigm instance of Postmodernist or contemporary art. But this is to take Formalism as a style, alongside Postmodernism, and not at all to touch the philosophy of art as such. That is not uncharacteristic of the history of the

philosophy of art. Philosophers have seized upon changes in style, and then went on to treat these as clues to what is philosophically distinctive in art—as philosophical discoveries in fact of what art really is—when what one wants and needs, philosophically, is what must be true of art irrespective of style—true of art as such, everywhere and always.

Meaning and embodiment were derived as necessary conditions for something being a work of art in my book *The Transfiguration of the Commonplace*, which took as its task to offer a philosophical definition of art. The book is an exercise in ontology—in what it is to be a work of art. But having an aesthetic idea—embodying, as Kant uses the phrase, *spirit*—is neither necessary nor sufficient for being art, as Kant's own formulation admits.

Remember what he says: "Asked what we think of a painting, we might say that it lacks *spirit*—though we find nothing to blame on the score of taste." Hence the painting can even be beautiful, as far as taste is concerned, but defective through lacking spirit. There must be plenty of art lacking in spirit. Pourbus's *Marie l'Egyptienne* lacked spirit in the sense that it lacked life, but, as we saw, that would not be Kant's conception of spirit. But there must be any number of portraits and landscapes that merely show their motifs, without doing more. Whatever the case, we are talking about more than form, more than design. You have to know something about lightning in order to grasp the power of Zeus through the fact he can hold bolts of lightning in his hands. You have to know something about sacrifice to see how Christ can be portrayed as a lamb. And you have to know something about

life for a novel to be considered as art. In a wonderful 1866 letter to her friend Frederic Harrison, just five years after writing her masterpiece *Silas Marner,* George Eliot wrote:

> That is a difficult problem; its difficulties press in
> upon me, who have gone through again and again
> the severe effort of trying to make certain ideas thor-
> oughly incarnate, as if they had revealed themselves
> to me first in the flesh and not in the spirit. I think
> aesthetic teaching the highest of all teaching because
> it deals with life in its highest complexity. But if it
> ceases to be purely aesthetic—if it lapses anywhere
> from the picture to the diagram—it becomes the
> most offensive of all teaching.

I treasure this paragraph: I feel that it is Kant speaking through the great novelist, who found, in her discovery of ideas made incarnate, the great secret of art. Eliot, of course, knew German philosophy. I am not a literary scholar, but I imagine she must have considered this a priceless find.

Some years ago I stumbled into an exhibition of David Hammons's recent work consisting of fur coats on stands, slathered with paint. What idea was embodied in this work? "A tableau of fashion and cruelty," wrote Okwui Enwezor in *Artforum,* but—referring to the fact that each ruined coat was spotlit—"their stately bearing . . . belied the strange deathly aura emanating from them." The former editor of the same magazine, Jack Bankowsky, saw the placement of these "artfully defiled furs" in "the bluest

chip of blue chip emporiums" as an act of hijacking, making "his public squirm." Both writers listed it as among the top ten works of the year.

It would have required some doing to explain this twenty-first century work to a late eighteenth century philosopher, but let's imagine what that would be like. The first thing would be to find a way of explaining the idea of animal rights to one of the greatest moral philosophers of history. It was not until Jeremy Bentham that the question was whether animals suffered, and whether we have any greater right to cause them suffering than we have to torture and kill one another. One would have to explain that activists on behalf of animal rights began attacking women who wore fur coats, until that point a garment of luxury. One main strategy was to spray the garment with paint, ruining it for fastidious wearers. Bankowsky says the furs are "artfully defined," implying that the artist has turned them into paintings, which Hammons has mounted on dressmaker forms, placed in an art gallery, and individually illuminated by overhead lights. The installation embodies the idea that animals should not be hunted down and slaughtered for the vanity of pampered women. Kant was a quick study. He could see how an aesthetic idea was embodied in David Hammons's piece, and even applaud it as an instrument of moral education. But would he thereby see it as art? It is not easy to imagine a conversation between David Hammons and Kant, but in my view Kant would regard Hammons as having won the argument. He would say, in effect, to Herr Hammons that he had found a clever counterexample—an aesthetic idea that was not a

work of art. For how could a constellation of ruined ladies' garments be a work of art?

The problem comes from thrusting a twenty-first century artwork into an eighteenth century art world—the age of the Rococo. The discontinuity between it and eighteenth century art is too great. But there were similar problems in the twentieth century. Andy Warhol attempted to give a certain Charles Lisanby a portrait of Elizabeth Taylor, but Lisanby turned it down on the ground that it was not art, and that "Andy knew in his heart that it wasn't art." In my first piece on the philosophy of art, I made the point that to see something as art required a quality the eye could not see—a bit of history, a bit of theory. What Kant needed, one might say, was a crash course in Modern Art 101. He would need to be brought to the point at which he could see that it could be art. That would require an education in which we would systematically remove the reasons he might give for thinking it couldn't be art. And much the same for Mr. Charles Lisanby. A Liz could have been bought out of Andy's first show at the Stable Gallery in 1962 for $200. It would bring $2–$4 million at auction today.

The basic philosophical point, however, is that art is always more than the few necessary conditions required for art. Let's consider a simple case, Warhol's *Campbell's Soup Cans* of 1962. The idea was unheard of until he did it. But he could have painted it like an Old Master, in chiaroscuro. There are endless ways of embodiment. He chose to paint the cans in an eight-by-four matrix, leaving no room for a thirty-third can. He painted the cans as if they were to be printed in a child's coloring book, completely

uninflected. Given the plenitude of choices, it must seem impossible to define art. Any choice is consistent with being art, but not necessary for it to be art. The most that can be achieved is what Kant and I have done—to have discovered some necessary conditions. I have no wish to judge between Kant's proposal and my own. Hammons could say to Kant that his installation would be art in 2008. There are reasons why Warhol's *Campbell's Soup Cans* would not have been art in the age of the Rococo. Someone could have painted them, of course. But what he or she would have painted could not have been paintings of commonplace objects—packages that everyone in Königsberg would be familiar with, as everyone in America was familiar with the soup cans in 1961. They would not have been Pop art in 1761. They could not, in 1761, have the meaning they were to have in 1961. Art is essentially art historical. It was destined to be preserved in art museums. It may have outgrown that destiny, but that is another story.

THE FUTURE OF AESTHETICS

A few years ago, the American Society for Aesthetics published two "call for papers" announcements on its web page, each for a conference on aesthetics as a neglected topic in the treatment of art. They were issued by two disciplines that do not ordinarily share a perspective—art history and philosophy. The organizers of each of the conferences appeared to agree that aesthetics is more central to art than either discipline had recently recognized. Art historians, according to the first call, having lately addressed art primarily from political and social points of view, are beginning to find merit in approaching it aesthetically. And philosophers of art, said to have focused almost exclusively on "how we define a work of art and the role played by art world institutions in that definition," now ask if they have

not lost sight of "what is valuable about art," identifying that with aesthetics. The question that interests me is what the impact will be if aesthetics really is restored to its alleged prior role.

By aesthetics, I shall mean: the way things show themselves, together with the reasons for preferring one way of showing itself to another. Here is a nice example. I was president of the American Society for Aesthetics when the organization turned fifty in 1992, and I offered to coax the artist Saul Steinberg, a friend, to design a poster to celebrate the occasion. Saul agreed to take the task on as long as he did not have to work too hard. He was not entirely certain what aesthetics was, but rather than attempting to explain its meaning, I had the staff at the *Journal of Æsthetics and Art Criticism* mail him a few issues so he could get a sense of what aestheticians think about. That was a lot to ask of someone who did not want to work very hard, but in the end, true to his character, Saul was much more fascinated by the diphthong Æ on the cover of the journal than with anything between the covers—if he even opened the issues (friendship has its limits). He phoned one day to say he had solved the problem, and I have to say, as an aesthetician, that he got closer to the heart of the matter than anyone who works solely with words could possibly have done. He had borrowed back from the artist Jim Dine a drawing he had done for him, which showed a landscape with a house with a big, blocky *E* next to it—the kind you see at the top of an optician's eye chart. The *E* is dreaming about a cosmetically enhanced and more elegant *E* than its current font allowed. This enhanced letter was displayed above in a thought balloon. All Saul did was replace the

elegant *E* with the journal's diphthong, and the blocky *E* was now dreaming of being a diphthong in much the same way the ninety-pound weakling in the physical culture ad dreams of having the abs and biceps that make girls swoon. That was aesthetics in a nutshell. And, of course, it could go the other way. The diphthong in its soul of souls might wish that it had the honest modern look of the blocky *E*. It is worth pointing out that there is not a scrap of difference in sound between a word containing the diphthong and the same word with a separated *A* and *E*. But differences in font are not mere coloration, as the logician Gottlob Frege would say: they contribute to the meaning of a text. There are always grounds for preferring one look over another. As long as there are visible differences in how things look, aesthetics is inescapable. I had three thousand posters printed and put on sale to members of the organization. What I found, not surprisingly, was that aestheticians were not enough interested in art to pay for the poster, and so far as I know, stacks of them are gathering dust in the organization's storeroom somewhere to this day. My hunch is that art historians would have snapped them up knowing the value of work by Steinberg, who died in 1999.

That brings me to the overall difference between the two disciplines in the present state of things. Philosophy has been almost immune to the impact of what, since the 1970s, has been called Theory—a body of largely deconstructionist strategies that has inflected nearly every other branch of the humanities—anthropology, archeology, literature, art history, film studies, and the like—all of which have been refracted through the prisms of

attitudes that were scarcely visible before the 1960s and have since flowered into academic disciplines with canons and curricula of their own, beginning with women's studies and black studies in the American university structure, and ramifying out into varieties of gender and ethnic studies—queer studies, Chicano studies, and the rest. These, I believe it fair to say, have been driven by various activistic agendas, which, in the case of art scholarship, criticism, and practice, have endeavored to alter social attitudes, purging them of prejudices and perhaps injustices toward this or that group. Deconstruction, after all, is taken to be a method for demonstrating the way in which society has advanced and reinforced the interests of special groups—white, for example, and male; and, along a different coordinate, western or North American.

Against this diversified background, it is worth reflecting on what a new focus on aesthetics in art history can mean. Will it simply become grist for these new disciplines—black aesthetics, Latino aesthetics, queer aesthetics—as such programs as *Queer Eye for the Straight Guy* suggest, where aesthetics is taken as one of queerdom's defining attributes, and where new gender attitudes are in the offing, as in the recently identified category of the metrosexual—straight guys with aesthetical eyes? Or does it mean an abandonment of the deconstructionist reorganization of knowledge, so that art will not be seen through the activist perspectives of recent decades, and instead be addressed "for itself," as something that affords pleasure to eye and ear irrespective of what we might consider the gendered eye, the ethnic eye, the racial eye, etc.? Or is the turn to aesthetics not so much an end to

the social and political way of considering art, but rather a prolongation of these into what might have been neglected dimensions, namely, female aesthetics, black aesthetics, queer aesthetics, and the like? In which case is the turn to aesthetics not really a change in direction at all?

"Theory" entered academic consciousness in the early seventies. The earliest of the writings of Jacques Derrida and Michel Foucault date from about 1961 and 1968, the year of university uprisings throughout the world. The events and movements that give Theory its activist edge in America date mainly from the mid- to late sixties: 1964 was the "Summer of Freedom" in America; radical feminism emerged as a force after 1968; the Stonewall riots, which sparked gay liberation, took place in 1969; and the antiwar movement went on into the next decade. Theory was then to define the attitudes of many who entered academic life by the eighties, and it became a sort of fulcrum that tended to split departments, mostly on the basis of age, between traditionalists, who tended to consider art Formalistically, and activists, whose interest in art was largely defined through identity politics. I know that aesthetics became politicized in art criticism by the mid-eighties. Conservative art critics insisted on stressing aesthetics as what those they perceived as left-wing critics neglected or overlooked. From the conservative perspective, the turn to aesthetics would mean the return to traditional ways. The fact that there is the call for papers on aesthetics from an art history department could be taken as good news for the conservatives. It would mean, in effect, what in France was called after World War I

rappel à l'ordre—a call to order—in which avant-garde artists were enjoined to put aside their experiments and represent the world in ways reassuring to those whose worlds had been torn apart by war. It would be exceedingly disillusioning to those who see things this way, then, if aesthetics itself were just a further way to think of art from the perspective of Theory. By the same token, it would hardly be thinkable that art historians whose syllabi, bibliographies, and reputations are based on political approaches to art should all at once turn their back on these and embrace an entirely new approach—one, moreover, that treats art as if gender, ethnicity, and the like no longer mattered. It would mean that they had finally thrown their lot in with the traditionalists. As academic and cultural life is now structured, this would be a tremendous transformation, but hardly one likely to be made.

The situation in philosophy is entirely different. As I have already mentioned, Theory has had virtually no impact on philosophy as an academic discipline in Anglo-American universities. Young people who went into graduate work in philosophy emerged from the same historical matrices as those who went into art history or cultural studies, but the kinds of concerns that created factions in the other divisions of the liberal arts somehow never did this in philosophy, and philosophy departments were rarely polarized along the same lines as other of *les sciences humaines*. The texts that split the rest of academic life into irreconcilable factions simply were not taken seriously as philosophy by mainline philosophers in Anglophone countries. In part, I think, this was because the language in which they were written was

perceived as grotesquely at odds with the standards of clarity and consequence to which philosophical writing was expected to conform. These standards were monitored by the editorial boards of the main periodicals for which articles were refereed. The principles of "publish or perish" Darwin-ized out papers written in the giddy new idioms. And since no one but other philosophers read philosophy any longer, there were no venues other than the standard journals.

Beyond that, philosophy never really presented itself as a candidate for deconstruction. The reason for this is that most of the main movements in twentieth century philosophy already consisted of programs for the reform of the discipline. Wittgenstein had declared that "most propositions and questions that have been written about philosophical matters, are not false but senseless. We cannot therefore, answer questions of this kind at all, but only state their senselessness." This was an extreme statement of a radical skepticism regarding traditional philosophy, the problem now being to find something philosophers could do instead. Phenomenology sought instead to describe the logical structure of conscious experience. Positivism dedicated itself to the logical clarification of the language of science. "Philosophy recovers itself," the Pragmatist John Dewey wrote, "when it ceases to be a device for dealing with the problems of philosophers and becomes a method, cultivated by philosophers, for dealing with the problems of men." Richard Rorty proposed that philosophers engage in edifying conversations with those in disciplines that knew what they were doing. So when Derrida or Foucault came onto the

scene, philosophy had survived so many wholesale critiques that it was, for better or worse, virtually immune to their attacks. What remained was a more or less neutral method of analysis that, had anybody been interested, could have been interestingly applied to some of the major elements of Theory, such as Derrida's famous thesis that "il n'y a pas de hors-texte," or Foucault's remarkable idea of epistemes, which define historical periods. Feminism in philosophy became a field of analytical philosophy, rather than a radical challenge to philosophy as unacceptably masculinist— and if it is true that there are ways of knowing that are inherently feminine, this might have found its way into the discussion without begging the question of whether there is a way of discussing such a charged position open to men and women alike. Most female philosophers today are feminists who, I think, do not see a need for deeply altering the nature of the discipline. It is, on the other hand, striking that the standard third-person pronoun is "she" or "her" in the standard journals, unless the subject is specified by name.

Except in the great era of German Idealism, aesthetics has been viewed as a somewhat marginal subdiscipline in philosophy, and its issues have not been considered sufficiently important to the practice of philosophy that philosophers other than specialists have seen reason to take much interest in them. So a reconsideration of aesthetics would have little, if any, impact on philosophy as currently practiced, by contrast with the impact it might have on art history. But the premise of the conference in London was that, to put it somewhat paradoxically, aesthetics

seems to have disappeared from aesthetics. That is, aestheticians, according to the conference's organizers, have made aesthetics so marginal to their analysis of art that they have forgotten, or failed to recognize, how important aesthetics actually is in art and the place of art in human experience. The call for papers went out in order to rectify this situation. It was a call to bring aesthetics back into the philosophy of art in some more central way than recent practice has acknowledged.

This is where I come into the picture, since I was singled out along with Marcel Duchamp as at least in part responsible for the way things have gone. Duchamp had indeed said that "aesthetic delectation is the danger to be avoided," and part of his intention with the famous readymades of 1913–17 was to constitute a body of art in connection with which aesthetic considerations did not arise. Duchamp clarified this in the talk I have already quoted, given at the Museum of Modern Art in New York in 1961: "A point which I want very much to establish is that the choice of these readymades was never dictated by aesthetic delectation. This choice was based on a reaction of visual indifference with at the same time a total absence of good or bad taste . . . in fact a complete anaesthesia." If all art were readymade, as Dalí once imagined could happen, there would indeed be no room—or at least little room—for aesthetics. But despite Duchamp's somewhat mischievous suggestion in "Apropos of Readymades" that "since the tubes of paint used by the artist are manufactured and ready-made products we must conclude that all the paintings in the world are readymades aided and also works of assemblage,"

it was clear that it required some special effort to identify works of art with the null degree of aesthetic interest. It was one thing to make room for art in which the absence of aesthetic interest was the most interesting fact about it, quite another to claim that aesthetics has no role to play in art at all. In his dialogues with art critic Pierre Cabanne, Duchamp makes it plain what his overall objective was, namely to modulate what he regards as the excessive importance given to what he terms "the retinal." In a way, he and the organizers of the London conference were reciprocals of one another. They were insisting that too little attention was being paid to something that he felt too much was being paid. He was saying that painting had functions other than providing aesthetic gratification—"it could be religious, philosophical, moral." They were saying that he had gone too far. It was not really much of a disagreement.

For me, Duchamp's philosophical discovery was that art could exist, and that its importance was that it had no aesthetic distinction to speak of, at a time when it was widely believed that aesthetic delectation was what art was all about. That, so far as I was concerned, was the merit of his readymades. It cleared the philosophical air to recognize that since anaesthetic art could exist, art is philosophically independent of aesthetics. Such a discovery means something only to those concerned, as I was, with the philosophical definition of art, namely, what the necessary and sufficient conditions are for something being a work of art. This, readers of this book will recognize, is what the book is about.

The problem, as I saw it—and still see it—arose for me initially

with Warhol and his *Brillo Box,* which was perceptually so like the workaday shipping cartons in which Brillo was transported from factory to warehouse to supermarket that the question of distinguishing them became acute—and this I took to be the question of distinguishing art from reality. I mean: distinguish them not epistemologically but rather ontologically—sooner or later one would discover that one was made of plywood, the other not. The question was whether the difference between art and reality could consist in such discoverable differences. I thought not, but from the beginning my strategy was to find how there could be differences that were not perceptual differences. My thought was that there had to be a theory of art that could explain the difference. A handful of philosophers were on this track in the sixties. Richard Wollheim phrased it in terms of "minimal criteria," which was a Wittgensteinian approach, and really did not meet the question, inasmuch as Wollheim supposed the minimal criteria would be ways of picking art out from nonart, and hence perceptual, which was to beg the question. George Dickie explicitly phrased it as one of definition, at a time when Wittgensteinians and others saw definition in art as impossible and unnecessary. I saluted Dickie for his daring but faulted his definition, which is institutionalist: something is an artwork if the Art World decrees it so. But how can it consistently decree *Brillo Box* an artwork but not the cartons in which Brillo comes? My sense was that there had to be reasons for calling *Brillo Box* art—and if being art was grounded in reasons, it no longer could be, or merely be, a matter of decree.

These, I think, were the main positions, and those who drafted the call for papers are clearly right, that aesthetic qualities played no role to speak in the ensuing discussions. Dickie built into his definition that a work of art is "a candidate for appreciation," and this could very well be aesthetic appreciation, but Dickie never wanted to be too explicit.

I have said at times that if the indiscernible objects—*Brillo Box* and the Brillo carton—were perceptually alike, they must be aesthetically alike as well, but I no longer believe this true, mainly because of having brought some better philosophy to bear on the issue. But this, as you will see, makes the issue of aesthetics more irrelevant than ever.

Let us attempt to distinguish between artworks and objects— *Brillo Box,* for example, and the particular stenciled plywood box in which any given token of the work consists. There were, perhaps, three hundred such tokens created in 1964, and a hundred or so more in 1970. The curator Pontus Hultén had approximately one hundred so-called Stockholm-type Brillo boxes made in 1990, after Warhol's death, but their status as art is pretty moot since they were fakes, as were the certificates of authenticity that Hultén had forged. It somewhat complicates the indiscernibility relationship that holds between the tokens that are art and the ordinary Brillo cartons, which happen to be tokens of a different artwork, namely a piece of commercial art. Warhol's boxes were fabricated for the Factory at 231 East Forty-seventh Street in Manhattan; underpainted in Liquitex by Gerard Malanga and Billy Linich; and then stenciled, using the techniques of photo-

graphic silkscreen, to look like grocery boxes. Warhol's grocery boxes—there were about six kinds in the Stable show—were what Malanga called "three-dimensional photographs." Meanwhile, there were many thousands of tokens of the cardboard Brillo carton, shaped and printed in various box factories (probably) in the United States over a period of time. Both of the boxes, one fine and the other commercial art, are parts of visual culture, without this in any way blurring the difference between fine and commercial art. We know who the commercial artist was—James Harvey—whose identity is complicated by the fact that he was a fine artist in the Abstract Expressionist mode who merely made his living as a freelance package designer. Now Harvey's work was appropriated by Warhol, along with the works of various other package designers in the 1964 exhibition at the Stable Gallery— the Kellogg's Cornflakes carton, the Del Monte Peach Half carton, the Heinz Tomato Juice carton, etc. But the only box that is generally remembered is *Brillo Box*—it was the star of the show and is almost as much Warhol's attribute as is the Campbell's Soup label. And this is because of its aesthetic excellence. Its red, white, and blue design was a knockout. As a piece of visual rhetoric, it celebrated its content, namely Brillo, as a household product used for shining aluminum. The box was about Brillo, and the aesthetics of the box was calculated to dispose viewers favorably toward Brillo. Warhol, however, gets no credit for the aesthetics for which Harvey was responsible. That is the aesthetics of the box, but whether or not that aesthetics is part of Warhol's work is another question altogether. It is true that Warhol chose the Brillo

carton for *Brillo Box*. But he chose for that same show five other cartons, most of which are aesthetically undistinguished. I think this was part of his deep egalitarianism, that everything is to be treated the same. The truth is, however, that I don't know what, if any, aesthetic properties belong to Warhol's *Brillo Box* itself. It was, though the term did not exist in 1964, a piece of Conceptual art. It was also a piece of Appropriation art, though this term was not to come into existence until the 1980s. Warhol's box was a piece of Pop art, so called because it was about the images of popular culture. Harvey's box was part of popular culture, but it was not a piece of Pop art because it was not about popular culture at all. Harvey created a design that obviously appealed to popular sensibilities. Warhol brought those sensibilities to consciousness. Warhol was a very popular artist because people felt his art was about them. But Harvey's box was not about them. It was about Brillo, which belonged to their world, since shining aluminum belonged to the aesthetics of everyday domestic existence.

An obituary of the brilliant young fashion writer Amy Spindler credits her with recognizing that "fashion was as important a cultural barometer as music or art." The question that leaves us with is, what marks the difference, if any, between fashion and art? A dress can be a work of art as well as a cultural indicator, but wherein lies the difference, since not all dresses are works of art? Hegel drew a distinction between two kinds of what he termed spirit: objective spirit and absolute spirit. Objective spirit consists of all those things and practices in which we find the mind of a culture made objective: its language, its architecture,

its books and garments and cuisine, its rituals and laws—all that fall under les sciences humaines, or what Hegel's followers called *Geisteswissenschaften*. Absolute spirit is about us, whose spirit is merely present in the things that make up our objective spirit. Harvey's boxes belong to the objective spirit of the United States circa 1960. So, in a way, do Warhol's boxes. But Warhol's boxes, being about objective spirit, are absolute: they bring objective spirit to consciousness of itself. Self-consciousness is the great attribute of absolute spirit, of which, Hegel felt, fine art, philosophy, and religion are the chief and perhaps the only moments. The aesthetics of the Brillo cartons tells us a lot about the objective spirit to which it belongs. But what if anything does it tell us about absolute spirit?

This is enough metaphysics for the moment. I have brought it in to help explain why, until I wrote *The Abuse of Beauty*, my work has had relatively little to say about aesthetics. The explanation is that my main philosophical concern, prompted by the state of the art world in the 1960s, was the definition of art. In a crude way, my definition had two main components in it: something is a work of art when it is has a meaning—is about something—and when that meaning is embodied in the work—which usually means: is embodied in the object in which the work of art materially consists. My theory, in brief, is that works of art are embodied meanings. Because of works like Warhol's *Brillo Box*, I could not claim that aesthetics is part of the definition of art. That is not to deny that aesthetics is part of art! It is definitely a feature of the Brillo cartons as a piece of commercial art. It was because of the

aesthetics of popular art that the Pop artists were so fascinated by popular imagery—commercial logos, cartoons, kitsch. But that is not to say, though I love popular imagery, that only popular art is aesthetic. That would be crazy, and it would be false. But it is also false to say that aesthetics is the point of visual art. It is not at all the point of *Brillo Box!* Nor is it the point of most of the world's art. This, in his dialogues with Pierre Cabanne, is what Duchamp more or less said. Aesthetics got to be part of the point of art with the Renaissance, and then, when aesthetics was really discovered, in the eighteenth century, the main players could maintain that the point of art was the provision of pleasure. Since art was taken as imitation, its purpose was to bring before the eyes of the viewer what was aesthetically pleasing in the world—pretty people, scenes, objects. In Hans Belting's great book *Bild und Kult* he discusses the "point" of devotional images from early Christianity until the Renaissance, in which aesthetics had no role to speak of. Images were prayed to and worshipped for miracles, like the *Vierzehn Heiligen* (fourteen holy helpers) of the German Baroque. But the cult of the Vierzehn Heiligen loved them for helping in difficult births, illnesses, bad fortune. Their unmistakable beauty is merely what was expected of statuary in the eighteenth century, not what the statuary was about. But if aesthetics is not the point of art, what is the point of aesthetics?

This is too swift. I don't want to deny that there may be art, the point of which is aesthetic. I'm not sure that I want to furnish examples of this yet, but I can say that most of the art being made today does not have the provision of aesthetic experience as its

main goal. And I don't think that was the main goal of most of the art made in the course of art history. On the other hand, there is unmistakably an aesthetic component in much traditional and in some contemporary art. Now, it would be a major transformation in artistic practice if artists were to begin making art, the point and purpose of which was aesthetic experience. That would really be a revolution. In paying attention to aesthetics, philosophers would be mistaken in believing they were paying attention to the main neglected point of art. But it may be, or rather, I think it is true that when there is an intended aesthetic component in art, it is a means to whatever the point of the art may be. And this certainly would be worth paying philosophical attention to, even if aesthetics is not part of the definition of art. And if, again, aesthetics really is an artistic means, then art history, in paying attention to it, is paying attention to how art, considered politically or economically or socially or however, achieves its goals. In brief, the reconsideration of aesthetics, whether in philosophy or in aesthetics, can tell us a great deal worth knowing about art, whatever our approach to it may be, as well as about the social world or—the world as objective spirit.

I want now to move to a rather deeper level, to a concept of aesthetics that almost certainly has some impact on how we think about art philosophically, but could have an even more significant impact on how we think about some of the central issues of philosophy itself. This is an approach to aesthetics that, because it is associated with one of the most respected names in modern philosophy, might recommend itself to philosophers inclined to be

scornful of aesthetics as a minor discipline, preoccupied by frill and froth. In 1903, William James arranged for the philosophical genius Charles Sanders Peirce to give a series of lectures at Harvard on the meaning of Pragmatism. In the lectures, Peirce specified three normative disciplines—logic, ethics, and aesthetics (what is right in thought, in action, and in feeling, respectively)—of which aesthetics was the most fundamental. Peirce believed that logic is founded on ethics, of which it is a higher development. He then says, surprisingly, in a letter to James in November 1902 that "ethics rests in the same manner on aesthetics—by which, needless to say, I don't mean milk and water and sugar." Peirce, incidentally, was unhappy with the term "aesthetics" and proposed in its stead the clearly unaesthetic word "axiagastics," which is the science that examines that which is worthy of adoration. In Lecture 5 Peirce said:

> I find the task imposed upon me of defining the
> esthetically good. . . . I should say that an object,
> to be esthetically good, must have a multitude of
> parts so related to one another as to impart a posi-
> tive simple immediate quality to their totality; and
> whatever does this is, in so far, esthetically good, no
> matter what the particular quality of the total may
> be. If that quality be such as to nauseate us, to scare
> us, or otherwise to disturb us to the point of throw-
> ing us out of the mood of esthetic enjoyment, out of
> the mood of simply contemplating the embodiment

of the quality,—just for example, as the Alps affected
the people of old times, when the state of civiliza-
tion was such that an impression of great power
was inseparably associated with lively apprehension
and terror,—then the object remains nonetheless
esthetically good, although people in our condition
are incapacitated from a calm esthetic contemplation
of it. [213]

Peirce derives the consequence that "there is no such thing as
positive esthetic badness. . . . All there will be will be various es-
thetic qualities." He wrote to James, jocularly, that "I am inclined
in my aesthetic judgments to think as the true Kentuckian about
whiskey: possibly some may be better than others, but all are aes-
thetically good."

I am not a Peirce scholar, and have no idea to what extent, if
any, these ideas are developed in any detail elsewhere in his vo-
luminous writings. But I have the sense that what Peirce had in
mind by aesthetic qualities must have been close to what Hei-
degger spoke of in *Being and Time* as *Stimmung*, or "moods." Hei-
degger writes: "A mood makes manifest 'how one is, and how
one is faring.'" To exist as what he calls *Dasein*—"being there"—is
always to be in some mood: "The pallid, evenly balanced lack of
mood, which is often persistent and which is not to be mistaken
for a bad mood, is far from being nothing at all." One of the moods
that Heidegger famously explores is "boredom" in his 1929 essay
"Was ist Metaphysik." In section 40 of *Sein und Zeit* he deals with

anxiety, or *Angst*. The state of mind that Sartre explores as Nausea is yet another example. I think terror, as exploited by the Department of Homeland Security, is a *Stimmung*—a mood in which everything is disclosed as threatening. I think what Kant designates as *Bewunderung und Ehrfurcht* before "the starry heavens above" is a mood in which sublimity is felt. When Wittgenstein says, at 6:43 of the *Tractatus,* "that the world of the happy is quite another than that of the unhappy" I again think that this is about moods, though the facts are entirely the same.

There is little doubt that certain works of art are intended to create moods, sometimes quite powerful moods. The Nazis' Nuremberg rallies are examples of mood manipulation. In the aesthetics of music, in some cases of architecture, and in many cases of movies, we are put into moods. Book II of Aristotle's *Rhetoric,* of which, according to Heidegger, "scarcely one forward step worthy of mention has been made," deals with these affects in a systematic way. What I admire in Peirce and Heidegger is that they have sought to liberate aesthetics from its traditional preoccupation with beauty, and beauty's traditional limitation to calm detachment—and at the same time to situate the beauty as part of the ontology of being human. But this would be put into the class of beautiful days or beautiful settings. And this put it into connection with natural objects, from flowers to the Grand Canyon, and is not what Hegel speaks of as "born of the Spirit and born again." It skips past artistic creativity.

My sense, in bringing to art the double criteria of meaning and embodiment, is to bring to art a connection with cognizance:

to what is possible and, to the faithful, to the actual. Gregory the Great spoke of the carved capitals in the Romanesque basilica as the Bible of the Illiterate: they show what the Bible tells us took place. They tell the uneducated what they are supposed to know. That is, they tell them what they are to believe as true. Beauty has nothing to do with it, though the capable carver presents the Queen of Sheba as the great beauty she was. It is possible that she looked that way. But it can be art without being beautiful at all. Beauty was an eighteenth century value.

"By defining Abstract Expressionist painting as a psychological event, it denied the aesthetic efficacy of painting itself and attempted to remove art from the only sphere in which it can be truly experienced, which is the aesthetic sphere," Hilton Kramer said as he accepted an award from the National Endowment for the Humanities in 2004. "It reduced the art object itself to the status of a psychological datum." If that is indeed what aesthetics is, an immense amount of Postmodern art has no aesthetic dimension at all, beginning with the work of Marcel Duchamp. Duchamp's Philadelphia Museum of Art installation *Étant donnés: 1) la chute d'eau, 2) le gaz d'éclairage*—which the viewer accesses through a keyhole—is low on aesthetics but high on eroticism. Much of contemporary art is hardly aesthetic at all, but it has in its stead the power of meaning and the possibility of truth, and depends upon the interpretation that brings these into play.

In my twenty-five years as art critic for *The Nation* magazine, my effort was to describe the art differently from that of the conservative taste of most of the New York critics. From my perspec-

tive, aesthetics mostly was not part of the art scene. That is to say, my role as a critic was to say what the work was about—what it meant—and then how it was worth it to explain this to my readers. That, incidentally, was something I learned from Hegel in his discussion of the end of art.

BIBLIOGRAPHY

Alberti, Leon Battista. *On Painting.* Translated with introduction and notes by John R. Spencer. Westport, CT: Greenwood, 1976.

Balzac, Honoré de, *The Unknown Masterpiece.* Translated by Richard Howard. New York: New York Review Books, 2001.

Cauman, John. *Matisse and America, 1905–1933.* New York: City University of New York, 2000.

Condivi, Ascanio. *The Life of Michel-Angelo,* 51. Translated by Alice Sedgwick Wohl, edited by Hellmut Wohl. University Park, PA: Pennsylvania State University Press, 1999.

Cropper, Elizabeth. *The Domenichino Affair: Novelty, Situation, and Theft in Seventeenth Century Rome.* New Haven: Yale University Press, 2005.

Danto, Arthur. *Andy Warhol.* New Haven: Yale University Press, 2009.

———. *The Transfiguration of the Commonplace: A Philosophy of Art.* Cambridge, MA: Harvard University Press, 1981.

Dewey, John. "The Need for a Recovery of Philosophy." In Dewey et al., *Creative Intelligence: Essays in the Pragmatic Attitude*. New York: Octagon, 1970.

Diamonstein, Barbaralee. "An Interview with Robert Motherwell," esp. 228. In *Robert Motherwell*, 2d ed., text by H. H. Arnason. New York: Abrams, 1982.

Duchamp, Marcel. "Apropos of 'Readymades.'" Lecture at Museum of Modern Art, New York, October 19, 1961, published in *Art and Artists* 1, no. 4 (July 1966). http://members.peak.org/~dadaist/English/Graphics/readymades.html.

Fry, Roger. "*Madonna and Child* by Andrea Mantegna." *Burlington Magazine* 62, no. 359 (February 1933): 52–65.

Gombrich, E. H. *Art and Illusion: A Study in the Psychology of Pictorial Representation*, 8. A. W. Mellon Lectures in the Fine Arts, 1956, Bollingen Series 35/5. Princeton, NJ: Princeton University Press, 2000.

Greenberg, Clement. "Affirmation and Refusals," 190. In *The Collected Essays and Criticism: Clement Greenberg*, vol. 3. Edited by John O'Brian. Chicago: University of Chicago Press, 1986–1993.

Hegel, G. W. F. *Aesthetics: Lectures on Fine Arts*, translated by T. M. Knox. 2 vols. New York: Oxford University Press, 1998.

Heidegger, Martin. *Being and Time*. Translated by John MacQuarrie and Edward Robinson. New York: Harper, 1962.

———. "What Is Metaphysics?" In *Pathmarks*, edited by William McNeill. Cambridge: Cambridge University Press, 1998.

Hibbard, Howard. *Michelangelo*. New York: Harper and Row, 1974.

House, John. *Nature into Art*, 75. New Haven: Yale University Press, 1986.

Kant, Immanuel. *Critique of Judgment*, translated by J. H. Bernard. New York: Barnes and Noble Books, 2005.

Kuenzli, Rudolf E., and Francis M. Naumann, eds. *Marcel Duchamp: Artist of the Century*, 81. Cambridge, MA: MIT Press, 1989.

Nicolson, Nigel, and Joanne Trautmann, eds. *The Letters of Virginia Woolf*, 2:420. New York: Harcourt Brace Jovanovich, 1977–82.

Peirce, Charles Sanders. "Lectures on Pragmatism." In *Pragmatism and Pragmaticism*. Vol. 5 of *Collected Papers*, edited by Charles Hartshorne, Paul Weiss, and Arthur W. Burks. Cambridge, MA: Belknap, 1935.

Pietrangeli, Carlo. *The Sistine Chapel: The Art, History, and the Restoration*. New York: Harmony, 1986.

Plato. *The Republic*, translated by Benjamin Jowett. http://classics.mit.edu/Plato/republic.html.

Schapiro, Meyer. *Words, Script, and Pictures: Semiotics of Visual Language*, 148. New York: G. Braziller, 1996.

Vasari, Giorgio. "Michelangelo." In *Lives of the Most Eminent Painters, Sculptors, and Architects*, translated by Gaston du C. de Vere. New York: Abrams, 1979.

Wittgenstein, Ludwig. *Tractatus Logico-Philosophicus*, 4.003. New York: Routledge, 2001.

Wollheim, Richard. *Painting as an Art*, 348–49. A. W. Mellon Lectures on Fine Art, 1984, Bollingen Series 35/33. Princeton, NJ: Princeton University Press, 1987.

ACKNOWLEDGMENTS

The only chapter that has seen prior publication is "The Future of Aesthetics," which served as a keynote address to an international conference on aesthetics held at the University of Cork. Only the first chapter, "Wakeful Dreams," has never been presented in lecture form. "Restoration and Meaning," an analysis of the controversial cleansing of Michelangelo's Sistine vault, was presented at Washington and Lee University in honor of Cy Twombly and Nicola del Roscio in 1996, but, like the remaining chapters, it has been revised. It was when my wife and I were guests in Gaeta, where I had gone to write a text on Twombly's sculptures, that he convinced me that those who denounced the cleansing were in the wrong. I am not an art historian, but my argument is ultimately philosophical, which is my only contribution to the

debate. Here it serves to support my claim that the definition of art is universal. If I knew enough about the caves at Ardèche to mount an argument, it would have resembled the basic claim of my essay on Michelangelo's stunning achievement. Or, for that matter, my long scrutiny of Andy Warhol's *Brillo Box*.

I purchased my first computer in 1992, and that meant that revising was incessant. "The Body in Science and Art" was delivered under the title "The Body/Body Problem" as a University Lecture at Columbia University and kept that title when, after many presentations, I gave the lecture at a conference on religion and philosophy—called Divine Madness—that was held at the University of Minnesota at Minneapolis and which was organized by Tom Rose of the art department. Tom and I had many interests in common, mostly in "Places with a Past," to borrow the title of an exhibition curated by Mary Jane Jacob. That led to a kind of collaboration, in the sense that I wrote essays for several of his artist's book projects. I asked Tom to read and comment on the manuscript of this book.

The chapter titled "End of the Contest: The Paragone Between Photography and Painting" was presented as a lecture at the Metropolitan Museum of Art in New York, organized by Lydia Goehr. It was based on some critical remarks I made at Columbia on the absence of photography from Peter Gay's book on Modernism. I have dedicated this book to Lydia because of our mutual philosophical interests—the philosophy of art and the philosophy of history—and our long friendship, her wit and generosity, and, possibly, the fact that we are both Capricorns.

I am deeply grateful to my editor, Jeffrey Schier, for his wonderful clarification of this philosophical text, even if I at times resisted clarity, hastening the reader to ponder the *Brillo Box* the way I did when I first beheld it in 1964. For me, it held the secret of art.

I am not aware of any special circumstance for which "Kant and the Work of Art" was written, but I presented it at the University of Maryland and later at the Crystal Bridges museum in Bentonville, Arkansas. My view is that any audience is flattered by a lecture on Kant, but I owe a great gratitude to Diarmuid Costello of Warwick University for awakening me from my dogmatic slumbers by showing me how much Kant and I have in common, particularly how close my views on criticism are to Kant's "aesthetic ideas."

This book was proposed either by my agent, Georges Borchardt, or by John Donatich, director of Yale University Press, perhaps because it might serve as a philosophical companion to my text *Andy Warhol*, which was published by this same university press. In any case, it enabled me to bring forward aspects of the concept of art that have dominated my philosophy and critical practice of the past half-century.

I owe to Randy Auxier the thought that my volume in the Library of Living Philosophers should have something to say about my career as a printmaker. I resisted, saying that artist and philosopher had nothing in common. But Ewa Bogusz-Boltuc discovered my work in an advertisement for a print gallery, and managed to get the museum at University of Illinois in Springfield to

give me my first show since 1960, as well as to write a spirited essay on the art of carving woodblocks. More than that, her essay made me realize that the passages on art in my work are always philosophical, so that I had to acknowledge that art and history are philosophically inseparable. I must further thank Sandra Shemansky for her taste in art by including a print of mine that had found its way into the collection she is responsible for, and by suggesting that I donate my woodblocks, sitting on a closet shelf for decades, to Wayne State University, my alma mater.

Finally I owe much of my happiness to the artist Barbara Westman, my wife for the past thirty-odd years. Her high spirits, her talent, and her love are gifts that really make life worth living.

Colalucci, Gianluigi, 59–61, 66, 70, 72, 75
collage, 100, 111
color: Condivi's disregard of, 63; Descartes's view of, 68; Mannerist, 56; Matisse's use of, 9–10; Michelangelo's use of, 60, 66; Renaissance painters' use of, 8; Vasari's disregard of, 68
color-field painting, 18
comedy, xi
comic strips, 44
commercial art, 43, 44, 150
Communism, 18
Conceptual Art, xii, 18, 34, 115, 116, 148
Condivi, Ascanio, 63, 67
connoisseurship, 5
copper plates, 18
Corday, Charlotte, 38, 39
Council of Trent, 119
Courbet, Gustave, 25, 108
Critique of Judgment, The (Kant), x, 76, 116, 117, 121, 126
Cubism, xi, 6, 7, 8, 12, 90; collages and, 111; movement disfavored by, 17
Cubo-Futurism, 18
Cunningham, Merce, 21

Dada, 18, 23–24, 25, 26
Daguerre, Louis, 101, 103–4, 113
daguerreotypes, 100, 101, 102

Dalí, Salvador, 13, 15, 143
dance, 51
Daumier, Honoré, 52, 110
David, Jacques-Louis, xii, 38–40
deconstruction, 137–38, 141
Degas, Edgar, 105
de Kooning, Willem, 11, 82, 84
Delaroche, Paul, 8, 101–2, 103–4, 112, 113
Del Roscio, Nicola, 54
Demoiselles d'Avignon, Les (Picasso), 4, 6–8, 32
Demuth, Charles, 27
Denis, Maurice, 61, 62, 64, 67
Derain, André, 8
Derrida, Jacques, 139, 141–42
Descartes, René, 45–46, 86, 87; color viewed by, 68; mind/body problem viewed by, 88–89, 90–91, 92–93, 94–96
De Stijl, 129
Dewey, John, xi, 141
Diamonstein, Barbaralee, 15
Dickie, George, 33, 145–46
Dine, Jim, 136
dioramas, 103
Discourse on Method (Descartes), 45–46
Doesburg, Theo van, 12
Domenichino, 118–20
Donatello, 8
doodling, 13, 15
Dove, Arthur, 11
dreams, 13, 45–46, 47–49, 51–52